Film Actors
Volume 15
Bing Crosby
Documentary study

Part 1

ISBN-13: 978-1503092013
ISBN-10: 1503092011

Copyright©2012-2014 Iacob Adrian
All Rights Reserved.

Dtp and graphic design

Iacob Adrian

Copyright©2012-2014 Iacob Adrian
All Rights Reserved.

Author statement

The actors and actresses are the the bricks .

The cast and crew are the plaster .

They stand on the foundation created by producers and writers and directors .

All these people creates the great palace of the art of film .

Iacob Adrian - 2013

Copyright©2012-2014 Iacob Adrian
All Rights Reserved.

The WOMEN

by Bing Crosby

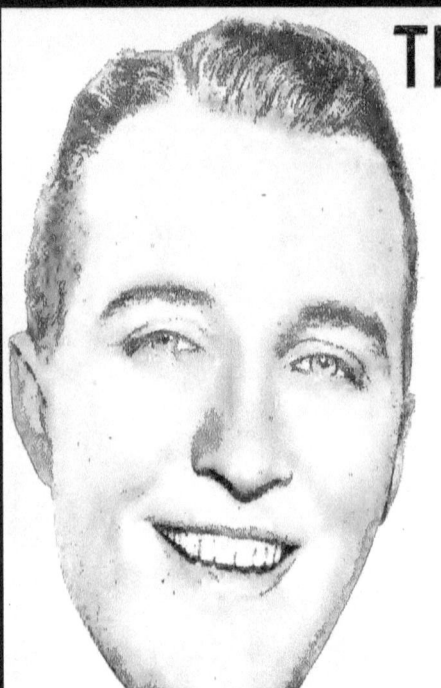

THE WOMEN IN MY life? That's a large order, for as Jimmy Durante would say, I got a million of 'em, a million of 'em! That sounds like boasting but it isn't—at least not when I admit that most of those millions are my fans—women who have heard me on the radio or seen me on the screen. A few are personal friends, more of them casual acquaintances; but out of those millions four women have had a direct influence on my life and my career.

I'd much rather sing you a song ... bo-boo-boo-boo than to write a story but since HOLLYWOOD Magazine has asked me to do it, here goes. But I warn you beforehand that there will be no literary flourishes, just the plain, unvarnished facts.

Somebody has said that if you look back along the road which any successful man has traveled, you will find one or more great women who left the marks of their influence upon his career. That is certainly true in my case. At each critical point in my career, one of four women has been at hand ready to inspire and help me.

The first, of course, was my mother—God bless her! The next was Mildred Bailey, now known on the air as The Rocking Chair Lady. The third was Elsie Janis and last, but far from least, is Dixie, my wife. Of these four, my mother and Dixie played the greatest parts in shaping my career. Mother saved me from being a lawyer and Dixie saved me from being a bum.

A smaller but highly important part has also been played by those who have written me the thousands of inspiring and encouraging fan letters that I have received during the past few years and those who have organized Bing Crosby fan clubs all over the country. I cannot continue without first paying tribute to these loyal fans.

• First let me tell you of my mother. She is Irish, with all the poetry and mysticism of her people. Her maiden name was Harrigan. She is a woman of deep sympathy and great understanding. Despite the many problems incident to raising a family of seven on a small income, she always had time to instil her children with the simple virtues of life which formed her creed. She is a natural musician, played the piano beautifully and sang in a sweet voice which I will never forget.

My father is a musician, too. He sang and played the guitar and our house was always filled with music.

Mother was quick to recognize my potential talents. As far back as I can remember she encouraged me to take up a professional career. She spent much of her time, as I grew older, in placing me in amateur theatrical productions, having me sing at church socials and letting me get experience in appearing before an audience. More than once she took money from her slender store of savings to buy me a new suit in order that I might make a good appearance on the amateur stage.

I was born in Tacoma, Washington, but we moved to Spokane when I was still quite young. I grew up in Spokane and it was there that I began to fancy myself as an actor. I didn't like to work, still don't; but I got a job as prop boy in a Spokane theatre just to be near the stage. I heard Al Jolson for the first time there and for weeks I entertained the family with imitations of Al's mammy songs. Later I organized a six piece band and played for local entertainments and dances but I got the idea that I wanted to be a lawyer so I enrolled in the law course at Gonzaga College. That suited my father first rate; but Mother wasn't so enthusiastic. She wanted me to go on the stage and eventually she got her wish. I had but six months to go to take my bar exam when I announced my intention of leaving school and following her advice.

A chap named Al Rinker and I decided to go to Los Angeles. Al had a sister there, Mildred Bailey, who was in the show business; we thought that she might help us get started. Father raised the dickens. He insisted that I stay and finish my law course and that is where mother, bless her, did a big thing for me. She talked father out of it and furnished Al and me the money to buy a second

A million feminine hearts beat faster when Bing Crosby sings, but there have

IN MY LIFE

hand Ford in which we started for California.

● We arrived in Los Angeles, broke and hungry, but Mildred Bailey took us in, fed us and gave us a room. She immediately assured me that I had talent and spent hours teaching both of us some of the tricks of the profession. It was she who gave us our professional start by taking us to Mike Lyman, brother of Abe, at the Tent Cafe in Los Angeles. Mike listened to us and gave us a job at $65.00 a week for the two of us.

I shall never forget the things that Mildred Bailey did for me. For a long time I despaired of ever getting anywhere but she wouldn't let me get discouraged. She kept me plugging, teaching me new things until at last Fanchon and Marco gave us a break. For a while we sang in theatres until we attracted the attention of Paul Whiteman. He gave us an audition and we clicked. Whiteman offered each of us $200 a week, and we were on the way. Yet without the inspiring counsel of Mildred Bailey I should have given up and gone back to Spokane to finish my law course and become an attorney in some small town.

Elsie Janis was the next woman who was a definite factor in my life. I met her at Paul Whiteman's house one night and she raved about my voice. Elsie was a big vaudeville headliner at the time and her praise did much to build my confidence.

"You've got it, Bing," she used to say, "and no matter what happens or how hard the going gets, stick with it and you'll be on top some day!"

I saw a great deal of Elsie while we were in New York. There was nothing romantic about it but she was a tonic influence and she, too, taught me tricks of the trade. A great woman and a grand woman, Elsie Janis, and it would be hard for me to put down on paper the things she did to my self-confidence and my self-respect.

● Then came Dixie Lee. Up to this time, girls had never played much of a part in my life. I'd gone out with a few, of course, but it didn't mean anything. Then I saw Dixie. A friend arranged a meeting and I went down for the count. I started giving her a big rush. She liked me, too; but we had a positive talent for quarreling. Frequently she would swear she never wanted to see me again; then I'd go on the air and sing *Just One More*

"If it hadn't been for Dixie, I'd still be a 'bum,'" says Bing Crosby in speaking of the love of his charming wife, Dixie Lee

Chance and believe me I put *feeling* into that song. I meant it. I guess I was pretty much of a "bum" in those days. I drank more than was good for me and although I made good money it didn't stick with me.

We'd fight again and I'd sing *I Surrender Dear* to her over the air and I meant *that*, too. I finally got to be too much for her and we were married in 1930.

But that didn't end the quarreling. Dixie had been a successful actress in her own right. She had certain ideas of her own. I had been accustomed to having my own way and doing what I pleased. I couldn't get used to the idea of living with someone who restricted me and made demands on my time. I suppose she went home to mother at least seven times during the first year of marriage but it wasn't serious. You see, we loved each other.

But at last the showdown came. She went home and I knew that this time she meant it. I began to take stock of

Please turn to page fifty-seven

been only four women who have guided his destiny and ruled his heart!

The Women In My Life

myself. I realized that I had lost her and that taught me the lesson in humility I needed. I went to her and told her that I had learned my lesson. We had a long talk and decided to try again. I *had* learned my lesson, too. A large portion of the conceit and selfishness had been taken out of me and we got along swell. Recently there was a report that we were contemplating a divorce but I want to say right now that it's all the bunk. We were never farther from it than we are right now.

IF IT HADN'T been for Dixie, I'd still be a "bum." But our reconciliation put me on a new track. I decided to quit drifting and make something out of myself. I'm not crossing any bridges until I get to them; but I'm not taking any chances with my financial future, either. That's why I've had myself incorporated under the name of *Bing Crosby, Ltd.* I'm president and my brother Everett, also my business manager, is secretary. And every cent I make is going into that corporation.

Dixie and I are trying to protect our future. We've built a home at Toluca Lake a few miles from Hollywood and there's a tenant in the nursery. His name is Gary Evan Crosby (although we call him *Gunder*) and that just about brings the story up to date.

I'm not much good at describing my feelings about things—the things that go on inside of me. When I used to croon a love song, it was more or less meaningless. But that was before I met Dixie and learned what love really means. When I go on the air and sing a love song now, it comes from my heart. I feel as though I want everybody listening in to be as happy and as much in love as Dixie and I are. And perhaps this new slant on life has something to do with my making better pictures, too.

I have an idea that I was expected to get more romance into this yarn. I'm sorry; but you see, I never had but one and it means so much to me that I sort of choke up when I try to write about it and I . . . aw, you know how it is.

And there you have the story of the women in my life—Mother, Mildred, Elsie and Dixie. They're grand women and I'm immeasurably grateful to every one of them. They've done a wonderful job, considering what they had to work with!

Why BING CROSBY IS QUITTING HOLLYWOOD!

The Ace of Crooners has found a ranch where a lazy man can enjoy life, and after one more picture he'll bid the screen goodbye

by ERIC L. ERGENBRIGHT

B ING CROSBY's quitting!
He has scored one of the most phenomenal screen successes of recent years, his steadily increasing army of fans are clamoring for more Crosby pictures, his film earnings would excite the envy of many a Wall street baron, but . . .

"As soon as this current filmusical craze has petered out —and it's just about washed up right now—I'm through! One more picture, perhaps, and a coast-to-coast road tour —and then I'm going to settle down on a California ranch and see how much real enjoyment a lazy man can find in sensible, leisurely living!"

An actor's theatrical gesture? Not at all. Bing means exactly what he says. He's telling Hollywood goodbye— *adieu*, not *au revoir*. He has already selected the general locale of his future home and every land agent in southern California is scouring the territory for that forty or fifty acres which is ideally suited to his purpose. Between pictures and over week-ends, Bing is examining the offered tracts.

" . . . I've found one ranch that fills the bill to a 'T,'" he declares. "It's near San Diego . . . in the hills, yet only a stone's throw from the ocean. I hope to close the deal within the next few weeks and start building there by early fall."

● Bing has earned a very considerable amount of money and he's lived sanely and economically. Without being a millionaire, his bankroll is fat enough that, with a little careful nursing, it should outlive him.

"The most idiotic of all ways to waste one's life is in the pursuit of applause," says Bing. He has a yen to raise blooded horses and—of all things—to can fish!

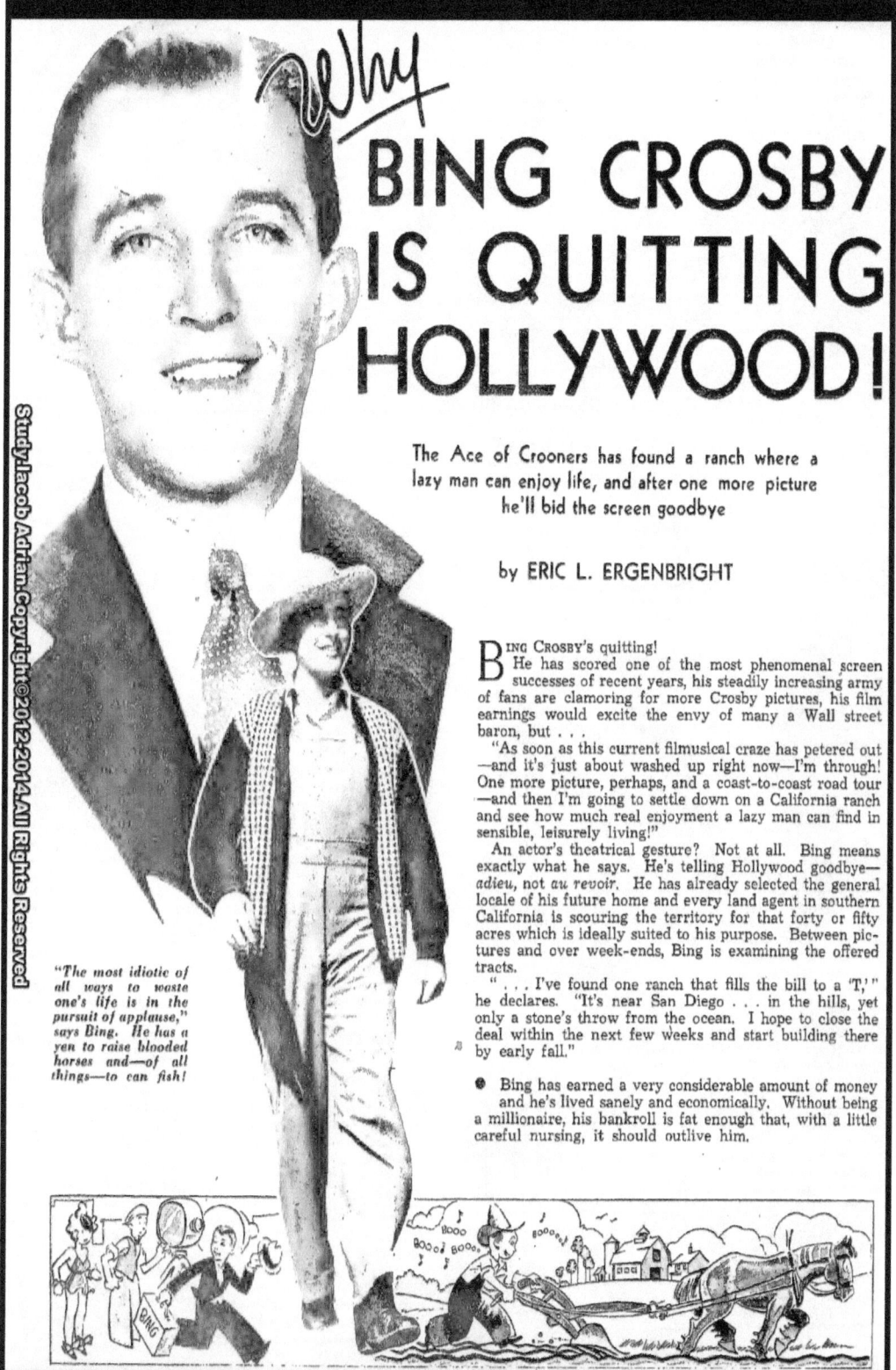

Stuart Erwin, Mrs. Evelyn Offield, who is Jack Oakie's mother; June Collyer, Stu's better half, and the Oakie lad himself snapped as they attended the opening of Biography in which Alice Brady is starring at the Biltmore theatre in Los Angeles

Why Bing Crosby is Quitting Hollywood!

"I HAVE ENOUGH to enable me to live the way I've always wanted to live," he says. "I'm going to enjoy life now instead of struggling to build up an unnecessary surplus. A man's foolish, in my opinion, if he goes on grubbing for money after he has accumulated enough to satisfy his needs. Neither Mrs. Crosby nor I have developed any 'champagne tastes.' We like to live simply, unpretentiously and comfortably.

"My idea of the most idiotic of all ways to waste one's life is to spend it in a pursuit of applause. That's just what many Hollywood stars are doing, and that's just what I will never do! There's nothing more pitiful than a one-time celebrity trying to cling to his fame long past his time. Why not recognize the inevitable and quit the game with some semblance of self-respect instead of frantically trying to hang on and ending as a laughing stock?

"I have no quarrel with pictures or with Hollywood. But there's no use in kidding myself; the screen is not my proper field. I'm not an actor—and I never will be an actor. Any screen success I've had is the result of a freak combination of circumstances. Frankly, I've my share of vanity and it's been properly flattered by my being recognized as a screen star. But again, what's the use of kidding myself? I'm just a singing voice—and whenever filmusicals go out, I'm on the way out too. Why prolong the agony?

"Naturally, I have no intention of being idle. I'm lazy, but I've always done work of some kind, and I can't believe that I would be content unless I continue to work. But I want to pick the kind of work that will pay me the greatest dividends in happiness.

"I intend to continue with radio, not only because it offers a very attractive income, but because I'm intensely interested in everything pertaining to radio. I plan to continue as a performer for the time being. Later, when my services as a singer are no longer in demand, I'll look for an executive position with some station or network. My experience should enable me to make myself valuable in finding and developing talent or in arranging programs. Also, I intend to try my hand at writing for radio.

"Whatever radio work I do will have to be done, principally, on the west coast. The Crosbys have planned for years to be ranchers—and ranchers they're going to be. When I buy land, I'm buying it for the one purpose of building a permanent home. And the ranch is going to be a business venture as well as an investment in sound, enjoyable living.

"I'm going to raise blooded horses. I'm convinced that fair amount of money is to be made in the breeding and racing of fine track stock. If I do no better than break even, I'll be richly paid in enjoyment.

"I expect to devote a great of my time to the fish canning business. As a matter of fact, I have been investing money for several years in a tuna packing plant which is owned and managed by my father-in-law. My investments there have earned a consistent and substantial profit.

Bing's decision to quit Hollywood is not the impulse of the moment. He has been laying plans in that direction for at least two years—and his plans were hastened by the advent of Gary Evans Crosby. Bing believes that a ranch is the proper place for a growing boy.

"Certainly I'm quitting," he states emphatically. "I couldn't back out now if I wanted to. I've promised the youngster a colt and he believes in holding a man to his word."

Bing Crosby

● When Bing sings the hearts of the feminine members of creation stand still (and the masculine contingent doesn't turn a deaf ear either) for he typifies romance, ideals and the refreshing reality of love's fondest dreams. His latest picture title sounds like a misnomer but it is interesting nevertheless—*She Loves Me Not*

Ann Dvorak

● Attention, bachelors! How would you like to have a *Housewife* like enticing, ravishing Ann Dvorak? No need to reply—we get you! We hope her screen husband treats her right in *Housewife*, her new picture, for she is indeed a honey to be loved, cherished—and obeyed! In real life, of course, her husband is Leslie Fenton

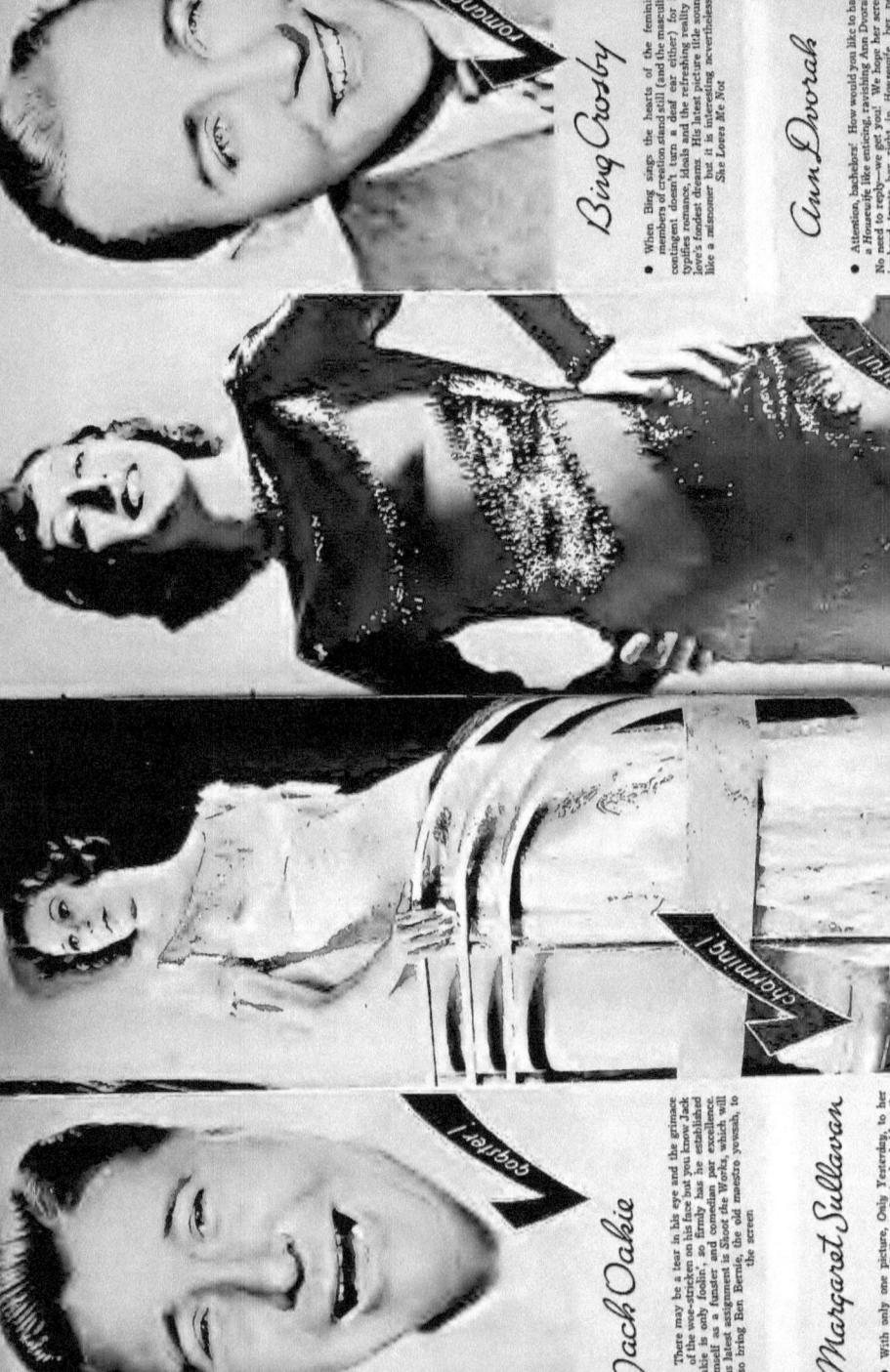

SHADOW of the "SNATCH" Hangs Over Bing

The threat against his eldest son has changed Bing Crosby's whole life ... This article is a revelation of the searing torment that has raged in his soul, concealed until now under the trouper's mask

by ELZA SCHALLERT

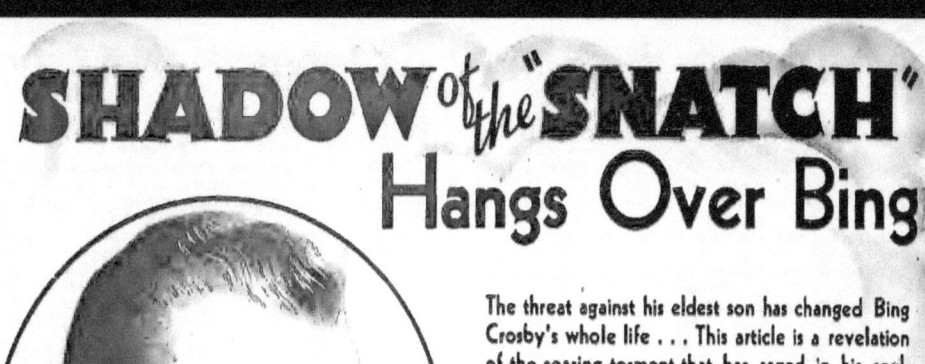

NOW THAT BING CROSBY and his wife, Dixie Lee, are the proud and happy parents of twin boys—which brings their sturdy little family up to three sons— I feel free to tell something that I purposely have withheld until the present.

It is the story of the terrible mental agony that Bing and his wife have suffered ever since the hideous kidnaping threat against their pitifully helpless babe, Gary Evan, six months ago.

It is the story of the searing torment that has been raging in Bing Crosby's soul, and the everlasting impression of somberness that has been branded upon his personality by this threat.

It is the story of the terrifying thoughts and devastating emotions that seethed in the mind and heart of Dixie Lee Crosby during those black, bitter hours when cruel, vicious hands seemed ready to wrench her first-born from her arms, the while she once again awaited motherhood.

Bing and I have had numerous talks about the changes that have come into his life ever since that terrible day when little Gary Evan was threatened with "snatching."

And I have hesitated until now to divulge what was said during those conversations which revealed so much of the Bing the public little knows, because I thought Bing would feel that it might

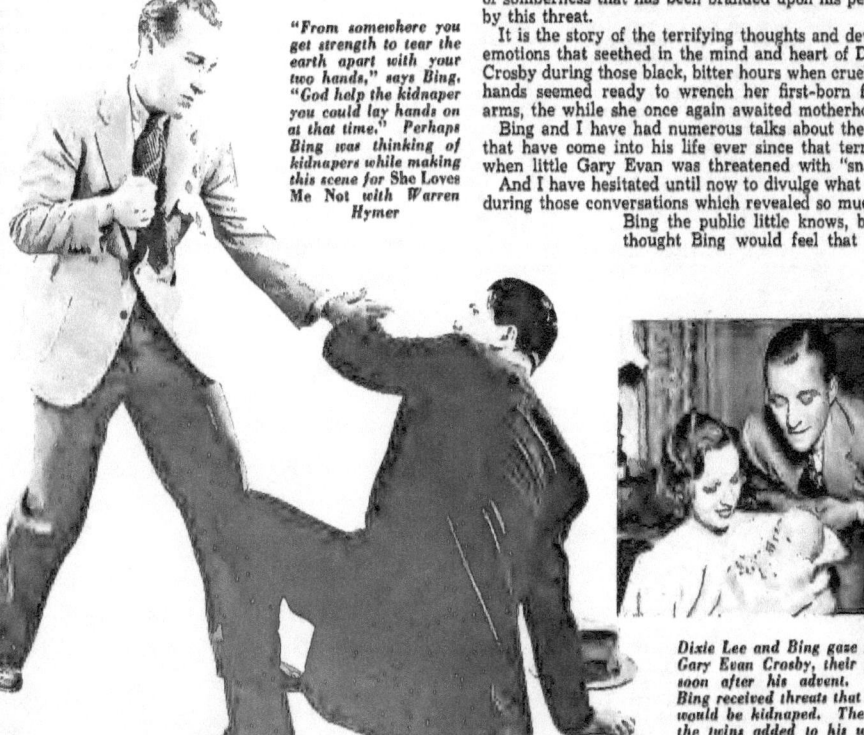

"From somewhere you get strength to tear the earth apart with your two hands," says Bing. "God help the kidnaper you could lay hands on at that time." Perhaps Bing was thinking of kidnapers while making this scene for She Loves Me Not with Warren Hymer

Dixie Lee and Bing gaze fondly at Gary Evan Crosby, their firstborn, soon after his advent. Recently Bing received threats that the child would be kidnaped. The birth of the twins added to his worries as well as his joy

Shadow of the Snatch Hangs Over Bing

sound like a play for sympathy on his part. And he is too much of a man to encourage that sort of thing. As he has often said to me, "Every one has his own griefs, troubles and periods of great trial. I don't see why mine should be magnified. But I do think that no one could ever overstress the courage and spirit of Dixie, my wife, during all of this time. She proved herself a great soldier. She had a hard and lonely battle to fight and win—a battle for calmness, self-preservation, to keep herself from going to pieces—because three lives depended upon it. The babies' and her own. It was the sort of battle that we men don't know much about. But all mothers do."

THE CROSBY HOUSEHOLD has become a joyous place, indeed, with the arrival of the twin sons, who incidentally were incubator infants, owing to their diminutive size—less than four pounds each, they weighed. However, a shadow hovers over the home notwithstanding, and probably always will. It is the menacing shadow of clutching hands.

I am convinced after my talks with Bing and other stars whose children have been likewise threatened by kidnapers that the ugly scar of this horror can never be removed from the heart and inner consciousness.

Certainly, it has wrought changes in Bing personally—not Bing, the professional singer and "crooner" that radio and film fans know. But Bing, the father, the man. He seems to be another person. He appears suddenly to have grown years older, deep within himself, and his prevailing mood is one of seriousness, of introspection. His friends, his family and his co-workers have commented upon the great change that has swept over him. Almost any stranger could detect that underneath his surface calm there is a turbulence ravaging his inner self.

There has also been talk about Bing's intention to quit the screen. Various reasons have been given for this. Bing himself has dodged the issue. He has fooled even the interviewers who have sought his purposes.

Few persons realize just what a smart person this Bing is. He doesn't tell everything he knows or thinks, ordinarily. It is characteristic for him to agree with writers and allow them to draw their own conclusions.

Gossip has been making the rounds that he is going to retire very soon to a ranch and become a gentleman farmer. He is sick of pictures and longs for the peace of the countryside, 'tis said.

I believe from my talks with Bing that he honestly wants to quit the screen, and the sooner the better. But I don't think the reasons advanced by gossip and surmise are the real ones. I believe the true and way down deep reason why Bing wants eventually to leave the film business is because of this kidnaping threat.

I believe that in it he has had a fulsome taste of the "magnificent rewards of Hollywood fame," and that he is completely fed up with the entire business of spotlighted glory and its heartbreaking aftermath of desolation and despair. I think after his recent new contract expires he will definitely retire from the screen—and possibly even before.

IN OUR LAST talk, just prior to the advent of the twins, he said:

"After all, it's an ironic climax to a film celebrity to have one's child, or children, forever faced by criminal threats. It makes all of the effort and the success of a career seem flat, useless. Every man works ultimately for one thing, and that's to build up the unit of the home with children. When you direct all of your effort toward that goal, and reach it to find that your home is threatened with destruction because of some peculiar trick of fame, of the spotlight, which throws everything out of proportion—well, you just feel you want to pack up your family, and take them away some place where you can stand guard over them yourself.

"That's why I've bought this typical old-time California ranch down in San Diego county, near the border. It almost adjoins Douglas Fairbanks' Rancho Santa Fe. I want a permanent home for my wife and children—a simple, beautiful, natural country place where the youngsters will have plenty of space to move around—and where we all will be isolated from too much spotlight stuff.

"That's the trouble with Hollywood. Everything is distorted by the limelight. We're all supposed to be millionaires and billionaires! And that's why we are always threatened with kidnaping and extortion.

"You know, if only the truth—the real truth—were told about film salaries, I believe the crime wave directed against Hollywood would stop. And we could enjoy life and our children and our homes, with the same peace and happiness that Heaven intended.

"With disturbed economic conditions in the country—men out of work, families losing their homes, children not getting enough to eat in many instances—it's understandable why bitterness fills the hearts of men who read about the

Yes, sir! It's Eddie Cantor himself, and that blues singer Ethel Merman in Eddie's new picture, Kid Millions. This first still will give you an idea. . . .

other fellow making a fabulous fortune when they have nothing themselves. I'd probably feel that way too, if conditions were reversed.

"But the terrible pay-off on all of this is that the phoney and highly colored figures about Hollywood incomes are printed, and not the correct ones. Articles never tell what we have left after the bills are paid!

"To begin with, the income tax automatically cuts our salaries right in half. Then there are commissions to be paid —not one commission of 10%, but usually two or three. After that come living expenses and all the hundred and one incidentals directly connected with our jobs and the peculiar position in which they place us. By the time everything in the way of absolutely necessary deductions is taken out of the gross income, it will be discovered in black and white that most of us in the Hollywood limelight today—with very few exceptions—are far from being rich. In my own instance, I feel if I can save around ten per cent of my yearly income I am lucky."

I HAVE ALWAYS admired Bing Crosby's intelligent action when he received the threat against his child. He went immediately to the police and department of justice officials, and laid his troubles in their willing and helpful hands. He didn't put on the big act of bravado and try to handle matters his own way

I wondered how the thought of having his helpless little son ruthlessly torn away from him and his wife affected Bing. I also wondered whether this embittered him against the world, or shook his faith in God.

As pointed out elsewhere, Bing is a more or less taciturn chap. He is given to action rather than words. I think it is a conscious gesture on his part, this matter of trying to keep his deep feelings to himself. And that is why I feel his free and unrestrained answers to my personal questioning have especial significance. They follow:

"Well. . . . the first thing that happens to you after a kidnaping threat against your child is that an icy fear lays firm hold on your heart. You're stricken numb by the shock. And then the reaction sets in almost immediately. You become a fighter. The fierce and cruel injustice of the thing enrages you and from somewhere you get enough strength to tear the earth apart with your two hands. God help the kidnaper that you could lay hands on at that time, provided it was a man to man fight, minus guns!

"And then after those primal emotions have passed, and reaction sets in, you reach out hungrily for your religion and philosophy and you pray. You pray for your child's safety. . . . for strength for your wife. and yourself, so that you can carry on your daily work and protect your home. Your faith in God isn't shaken in that kind of a dark hour —it becomes a stronger and mightier force. That just about tells it, I guess."

I ASKED BING if his routine of life had been changed.

"Yes, your routine of life does change, and so does your psychology. For one thing, your freedom is cut off with one sharp blow. You no longer slap a hat on the back of your head and hop into your car to go where you please. You pack a gun on your hip and a bodyguard follows along. Your home is protected by armed guards day and night. You are constantly surrounded by a little arsenal.

"The thing is that you suddenly, and perhaps forever, live under a shadow. It's been hard for me to get used to such a new condition of living and new psychology, because I have been completely free all of my life.

"You go along in a happy, care-free manner year after year—the sky is serene, and the world a wonderful place to live in. And then one day, without any warning, a black curtain drops, shutting you off from the world you thought was so marvelous, and you find yourself isolated and very much alone. Things don't look quite so good as they once did, and you feel a little soured on the world of men!"

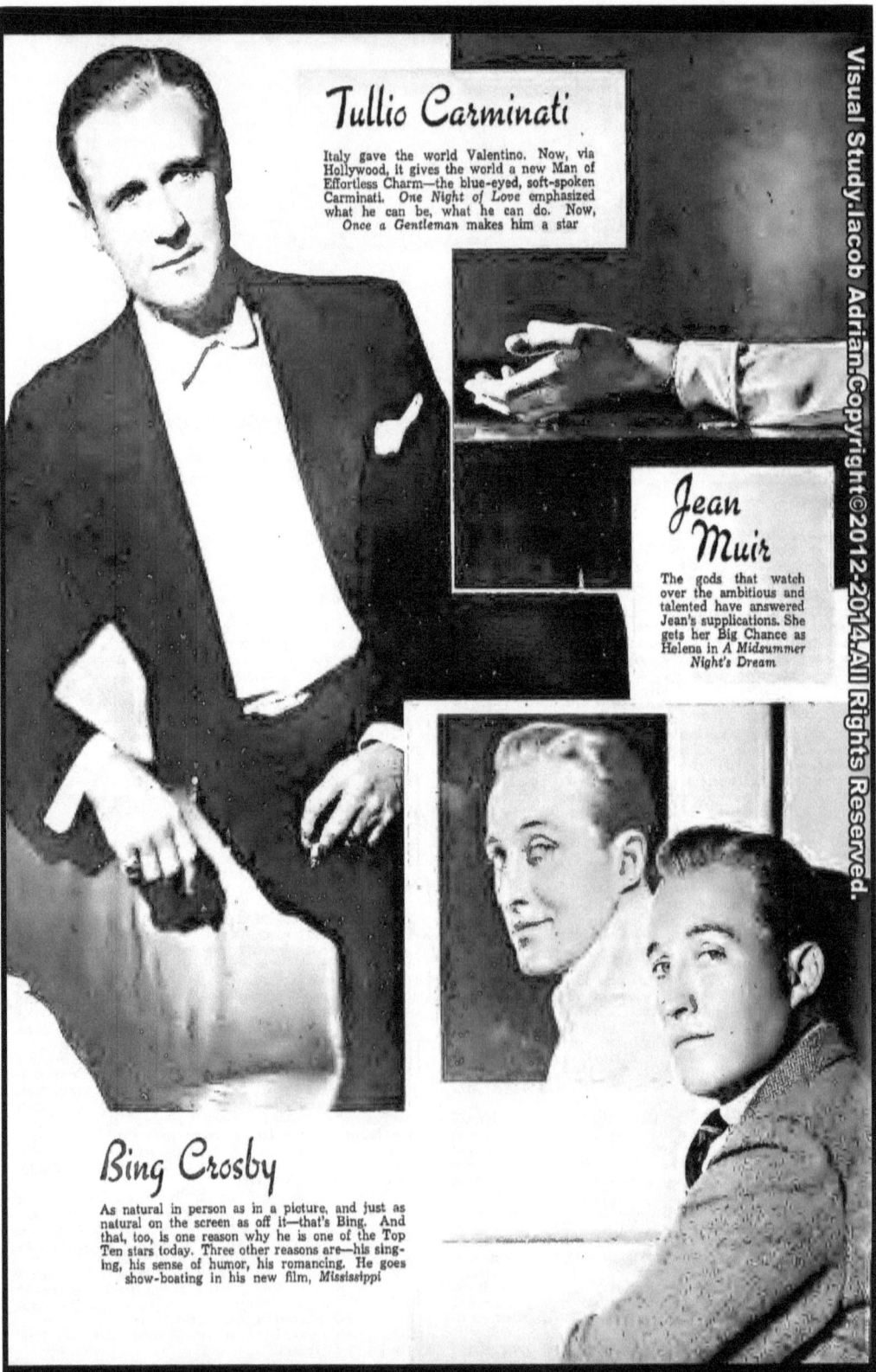

Tullio Carminati

Italy gave the world Valentino. Now, via Hollywood, it gives the world a new Man of Effortless Charm—the blue-eyed, soft-spoken Carminati. *One Night of Love* emphasized what he can be, what he can do. Now, *Once a Gentleman* makes him a star

Jean Muir

The gods that watch over the ambitious and talented have answered Jean's supplications. She gets her Big Chance as Helena in *A Midsummer Night's Dream*

Bing Crosby

As natural in person as in a picture, and just as natural on the screen as off it—that's Bing. And that, too, is one reason why he is one of the Top Ten stars today. Three other reasons are—his singing, his sense of humor, his romancing. He goes show-boating in his new film, *Mississippi*

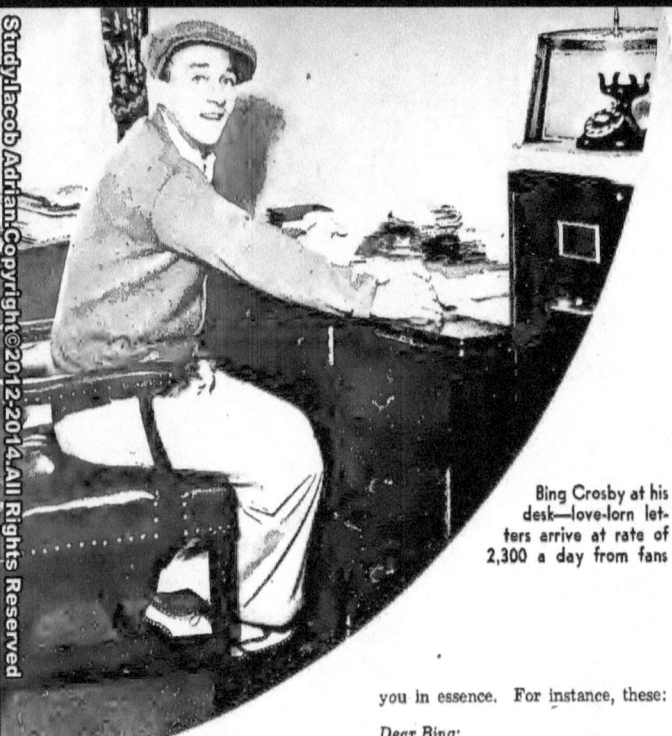

Bing Crosby at his desk—love-lorn letters arrive at rate of 2,300 a day from fans

HOLLYWOOD SPOTLIGHTS

the dance Tom grabbed my hand and pulled me outside and shoved me into the roadster. He drove like a fiend. When we parked in our old spot we didn't waste time with explanations. We both understood that it was just stubborn pride. But we're not going to take any more chances. We'll be married next week. Wish us luck, old pal. And thanks—

—BETTY.

The following cry of anguish is worthy of any anthology:

Bing—

He did it! For six months he's been threatening to leave me and last night he did—for good. When I came home from work I found his note pinned on my lounging pajamas in the closet. What can I do? I can't go home. I don't want to go on living without him. I know I've done wrong but please—please help me as I haven't a friend in the world. Sing Body and Soul the next time you're on the radio. He'll understand. I want him to know how much I love him still. He—I'm crying so hard I can't go on.

—RUTH.

This impertinent letter must be included because of its sheer audacity:

Bing dear,

Can you take it? I've been listening to you and loving you long enough. Too long, really. I just received $1000 from the estate of an uncle—God rest his soul—so I'm hopping the next plane for Los Angeles. I'm coming out to the studio for just one kiss. Then I'll be content. I know you're married but I'm just five feet four of healthy, young girl so one kiss won't hurt. Well, as the nudists say—I'll be seeing you.

Devotedly,
—WILMA.

P. S. Remember the name when I pass thru my card.

The following confession is from one in the "awful age."

Dear Bing,

I wish I could die! I'm just an old maid and ugly. All my life I've had to watch my sister attract all the eligible males in town. You don't know how terribly lonely it is to sit at the window of my room and look at the moonlight and listen to Sis and some beau whispering on the porch. Nobody loves me. When I'm dead they won't even understand that I died of a broken heart.

Life's worth living! Just after I wrote the first part of this letter something tremendous happened. Harry came for Sis. She had gone out with another suitor. I went downstairs to see what the rumpus was about and Harry asked me to go out on the porch. He wanted to talk about Sis.

How Crosby Plays Cupid

TWENTY-THREE hundred and more letters a day—all on love—have given Bing Crosby the title of Cupid instead of Crooner around the Paramount lot. We looked into the matter the other day, and it's a story well worth relating.

It all came up because of what a young man told me. He had taken his girl friend riding. Under a clump of oaks, where the moon peered through lacy foliage, the car stopped. But in spite of the romantic setting, the mood did not seem complete. The boy turned on the radio . . . and suddenly romance is theirs, and love is in the air. Crosby is crooning!

More lovers have been brought to speak of rose covered cottages and wedding rings because of Bing's voice than any statistician could hope to count. This was but one of thousands of similar couples—and Bing's fan mail proves it.

So let us delve into those bulging bags. Bing of course won't let us reprint real names, but we can note the sense of the letters and give them to you in essence. For instance, these:

Dear Bing:

Pardon the familiar salutation but Tom and I discuss you so often that we feel that you are almost one of us. If you could hear from your end of the radio as well as we do from our's you'd know the reason why! And sometimes I feel that you can!! That brings up the reason for this letter.

Last month Tom and I quarreled. Oh, we've had occasional spats all right during our six months engagement but this time it was really serious. To prove his independence he began rushing Molly—she's the flirt of the town. I couldn't let him get away with that so I started vamping like mad. Then it happened. He came over to the house one night and asked me to return his ring. He couldn't meet my eyes when he said Molly and he had decided to marry. Well, I ended our engagement in the approved style. I walked with him to the door and said something that was supposed to be funny. Then I collapsed.

I don't know how I lived thru the next few weeks. That is—up to last night. Last night we had our monthly dance at the country club. I went with Wade. Tom and I wouldn't look at each other. But while we were dancing Wade asked Molly for the next and Tom very impersonally mumbled to me. I accepted just as coldly.

We didn't say a word thru the entire dance. I guess we were both thinking too hard. For the number they played was Down The Old Ox Road. That was the song we heard you sing when we first went out together. And the one you happened to sing when he slipped the solitaire on my finger. After

How Crosby Plays Cupid

was terribly jealous and wanted to find out if she really cared for him. We sat down on the swing. Thru the open window came your voice from the radio. The way Harry talked I realized he didn't know anything about Sis. He was in love with his illusion about her. His ideal.

Then I made my gigantic discovery. As we lay back on the swing listening to you croon it came to me suddenly that men love only the illusion which they, themselves, have created. Really love, I mean. Even an ugly girl—if she's not too ugly—can conform to their ideal. I moved closer to Harry. I talked in such a way that he'd understand that I fit into his pattern. In a little while he was holding my hand. It was a beautiful hour. When he left he asked if he might see me again. Was I thrilled! I'll be an old maid no longer! Fortunately, I made this discovery early enough in life. Next month I'll be seventeen.

With all my grateful heart for your help,
—HAZEL.

Here is a letter which is almost the opposite:

My Dear Bing Crosby:
I'll admit that I'm not one of your fans. I'm just an old-fashioned mother. But my young daughter worships you. Even at the dinner table she won't permit us to talk or make any sound when you're on the air. She always listens with a rapt expression. I've tried to bring her up as a good, wholesome girl. But I've failed. We have terrible scenes occasionally. Even when I forbid her to go out she steals down the back stairs. She seldom comes home before two A. M. She thinks it smart to smoke and drink and neck—I hate that word!

Won't you do me a favor? You have such a tremendous influence on Katherine. And I appeal to you as the father of children of your own. Won't you write a song extolling the old-fashioned virtues? Teaching the younger generation that true happiness comes only from the wholesome things in life? If you do, thousands of parents will be grateful. I know it is silly to lay any blame on you but I'm just an anxious mother.
Your sincere friend,
—MRS. R. E.

The next letter strikes a note of tragic simplicity.

Mr. Bing Crosby:
Maybe you git no letters from men but I gotta wite you to say somethen. I bin sitten here for three days now drinken and listen to you sing on the gramaphone and rememberen when Ella was here. I killed four quarts but I cant git drunk. I lose my job to because I dont go back to work but I dont care. Ella says when she left that shed git the divorce when she makes enough money and for me to take care of myself and not to worry. I dont blame her for leaven for shes much better off by herself. I only wish I didnt love her so much. Thats a hellava thing to love a woman so dam much your crazy and still do her no good when your around. But what I mean to write is that Ive put the revolver away. I somehow play your record THANKS on the gramaphone and know I feel the same

way to. She give me four years of happiness which I dont deserve I guess. So thanks for all . . . And thanks to you to. You save my life even if it aint much good.
—KARL.

Forgit to say you sing that song dam good. Maybe you know how it is to feel like I do now.

The next letter should not properly be included. It is not the least bit typical. But your commentator found it irresistible. Judge for yourself.

Honorable Bing:
Perceiving my unmentionable debt to you I now little bit repay same. Accept, Honorable Sir, my colossal gratitude. Tenya have little eyes for me when I first make arrival from Japan. She American citizen. Me, she call—cock-eyed dope. Unusual words which I do not understand at time. Soon learn, though. And I experience most dejected sensation. But my heart will not permit dictates of horse sense judgement. Keep using phone in beseechings for date. Her respectable mother intercedes in my besides. We go out. I mutter sweet wordings about moon holding ocean in gentle embrace. Tenya say—Ah nuts. That observation very disturbing. But I persist with my Don Juaning. All time learning more of language and manners uncouth but ardent. One night, we quarrel. I go to hell in approved stylishness and end up in hospital from too abundance of Saki. Tenya and hon. mother come for visit. Parent make flutter with eye as she adjust radio to your commodious voice. She tip-toe out. Tenya and I alone. I recline on pillow with ears imbibing pleasant sensations. T e n y a commits hand to my brow. I peer up. I disclose she is thinking most tender thoughts. I do action in this crises. I seize other hand desperately. I implore her to become hon. wife. She smile and answer dreamily—And will you cherish me always like moonlight on the water? I respond—Hell yes. After Justice of Peace enact strange ceremony our lips perform sweet American custom. Very satisfactory. Tank you so much.
Your humble servant,
—SESUE.

A great many letters come to Bing daily, typifying another type of love—mother love. Letters similar to the following are most frequent arrivals:

Dear Mr. Crosby:
Our daughter, Mary, disappeared from her home six months ago, and we haven't been able to locate her.
We are heart-broken and don't know what to do next.
I do know this, though. Wherever Mary is, I know she will be listening to your program on Tuesday night.
Please help us, Mr. Crosby, and tell her over the radio to come home.
—A HEART-BROKEN MOTHER.

But Bing is not permitted, by radio station rulings, to broadcast such personal appeals.

Next time you see him in a movie—and look at *Mississippi* for proof of what I say—notice how everybody starts holding hands when Bing starts singing. That, friends, is Cupid himself at work!

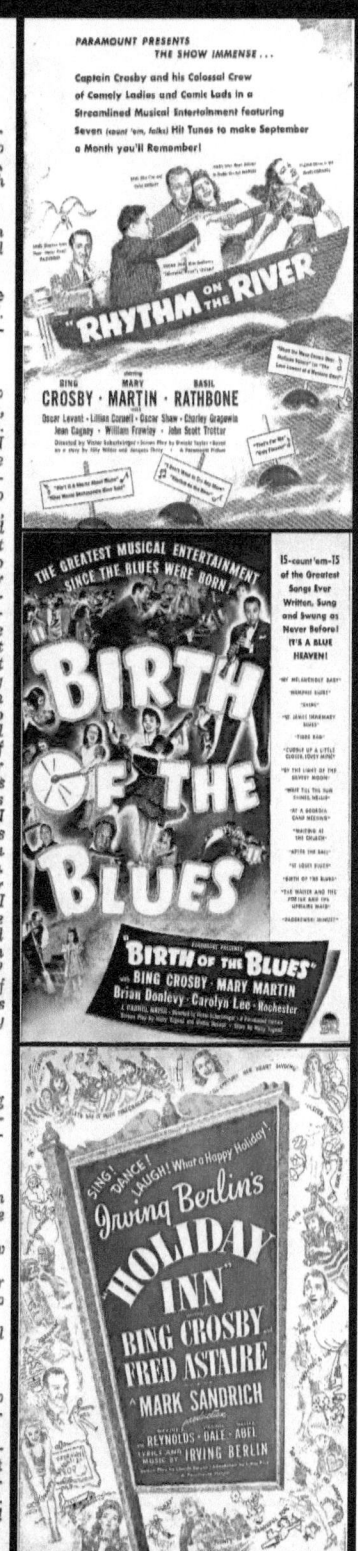

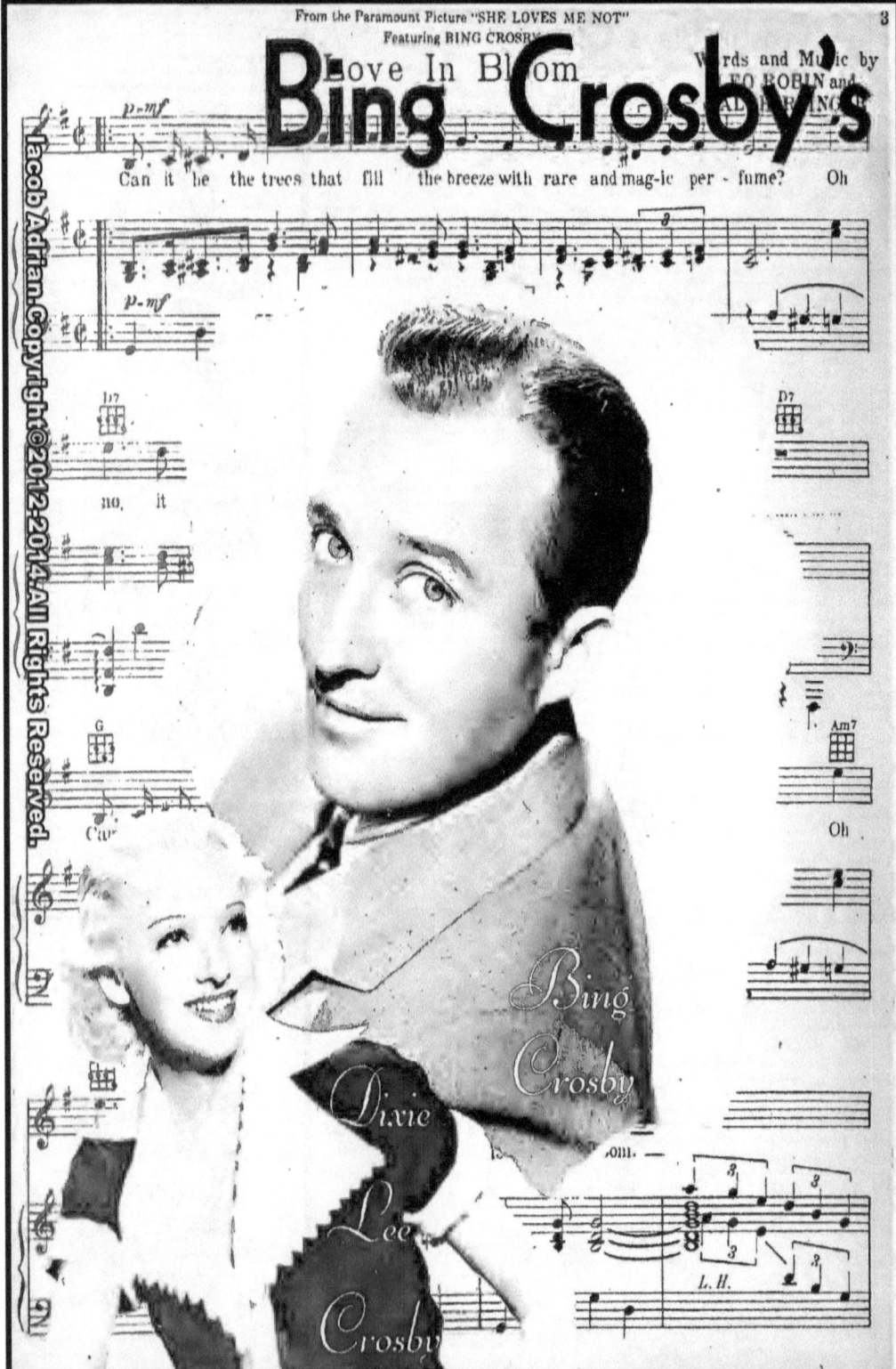

Song of Love

Words by William Ulman, Jr.

PIRATE SONG

Fif-teen men on the dead man's chest,
Yo! Ho! Ho! and a bottle of rhum!
Drink, and the devil had done for the rest,
Yo! Ho! Ho and a bottle of rhum!

● IT WASN'T the good ship Lollypop in those days. It was the bad ship Black Heart, a four-masted vessel flying the skull and bones at her mast head and manned by as vicious a crew as ever struck terror to the hearts of peaceable shipping in the orchard of the Crosby family in Tacoma.

The crew of two were sitting on a dead man's chest, singing loud enough to be fifteen able-bodied pirates, while they swilled down large quantities of lemonade out of a milk bottle labeled "RHUM!" and decorated with a skull and bones. It was all very piratical until the dead man got tired of having his chest sat on by two older brothers and insisted on having some of the lemonade, too.

"Aw, shucks, Harry! You're dead; you can't drink rhum when you're dead, can he, Ted?"

Brother Ted agreed with brother Ev despite younger brother Harry's disgust. After all, elder brothers have to stick together, don't they?

"Well, I'm tired of being dead. It's my turn to be Captain and Ev's turn to be the Spanish gallon and get killed."

"Gall-yon, dead man, gallYON! Gallons is what you drink after you've caught a galleon."

"Who drinks? Goshallhemlock! I'm always the one as gets caught and you two do all the drinking. . . . Now, lookahere! It's my turn to be captain and drink rhum. I been dead three times in a row!"

● THE BAD ship Black Heart lay in wait behind a mulberry bush for the Spanish brigantine, heavily laden with Peruvian gold and Washington lemonade. The unwary victim sailed out from the lee of an apple tree and the action was joined. Captain Bloody Harry bawled an order which was gleefully taken up by his crew, Terrible Ted.

"Avast and belay! Ship ahoy! Heave to!"

"Never!" came the answer from the courageous Spanish shipmaster, "I'll die fighting! . . . Boom!"

Undaunted, the pirate ship pursued, "Fire when ready!" Ted bang-banged as a good crew should. In the excitement Bloody Harry left his quarter deck and manned a gun.

"Bing! Bing! . . . Bing-bing! . . . Bing!

His brothers stopped in disgust. "Aw, shucks! You're no good as a pirate captain! Pirate captains don't go bing! They go boom! or bam!, but not bing. Bing's a sissy noise for a cannon!"

"It is not! They do so! Ask any pirate!"

And "Bing" it's been every since! Just ask him.

SHADE OF THE OLD APPLE TREE

In the shade of the old apple tree
Where the love in your eyes I could see
When the voice that I heard,
Like the song of the bird,
Seemed to whis-per sweet music to me:

● HARRY CROSBY, SR., was plunking on his guitar and staring dreamily off into nowhere, his back against the bole of an apple tree. It was a Saturday afternoon and he was home from the brewery where he worked as accountant. Somehow, it seemed fitting that he should wander idly through a few bars of "In the Shade of the Old Apple Tree."

Papa Crosby didn't get through many bars before a large apple fell squarely upon his head. It was not until he heard a tell-tale giggle from somewhere in the foliage overhead that he realized that someone or two of his brood were seeing by practical experiment if Newton and his gravitational discoveries were actuality or fable. Nor did he realize he was participating in what was to be forever afterwards the most precious legend in the Crosby family about young Bing.

Mr. Crosby never turned a hair or missed a beat. He continued to stare off into nothingness as though apples were always falling with a giggling sound and hitting him on the head.

He munched on the apple and at length called out, "Thanks, kid, that was swell!" before resuming his strumming.

Free of restraint now that they had been openly discovered, the two kids started to play around in the tree. At the end of the bough—where they always are—was an exceptional apple that both boys discerned simultaneously. It goes without saying that they both started for the apple with loud protestations of having seen it first. It was just another mad scramble until

Ev got Bing by the shoulder and gave him a push intended to convince that older brothers had priority in the matter of apples. They were both appalled by what happened. Bing's leg slipped, he lost his balance, clutched wildly at the limb, missed and fell to the ground.

Unless you've heard a bone crack you'd never understand the sound, so there's no use trying to describe it.

● THE GUITAR lay on the ground, gathering the evening dew. The apple tree was deserted.

In the house, the doctor had just left. Everett sat at the foot of the bed, looking pitifully penitent and trying to think of something to do to prove he was sorry. Naturally, he couldn't. He was a young boy—and they're always most inarticulate when they're most affected.

Dad sat at the side of the bed. He, too, was trying to act as if everything was really okay.

"How you doin', son?"

"Okay, Dad. . . . It kinda hurts a little where the splints are."

"Yeah. I s'pose it does."

"You were singing, 'In the Shade of the Old Apple Tree' just before it happened, weren't you, Dad?"

"Un-hunh."

With a mighty effort at lightheartedness the kid spoke up. "C'mon. Let's all sing it . . . hunh?"

"No. . . . Better get some sleep, son," said Dad as he headed for the door. "Come on with me, Ev."

Bing called his father back when he heard Ev clatter down the stairs.

"Say, Dad. . . ."

"Yes, son. . . ?"

"Say, I hope it didn't hurt you none when that apple hit you on the head."

"Shucks, no, old timer! Just an apple on the head doesn't bother you much when you got seven kids!"

Bing grinned feebly, "Thanks, Dad. . . . G'night."

"Good-night, Bing." Dad stumbled on the top step going down stairs. Somehow or other, he couldn't see so well just then.

Bing Crosby's SONG OF LOVE

Just one more chance, to prove it's you
Alone I care for,
Each night I say a little prayer for
Just one more chance.
Just one more night to taste the kisses
That enchant me,
I'd want no others if you'd grant me
Just one more chance....

Dixie Lee and the twins

A musical life story about a famous crooner, this authorized biography will send old tunes rippling through your mind and bring you a stirring picture of Bing Crosby's life

by
WILLIAM ULMAN, Jr.

BING HAD SUNG his way through life from the pirate days in the big orchard out in Tacoma to the night when he sang his song of surrender to Dixie Lee at the Cocoanut Grove. They were married a short time later while Bing's following was growing even greater. And then a discordant note crept into their lives.

Bing gradually became aware of the fact that two don't live as cheaply as one. He hit the Grove for a raise which he and his co-singers felt they deserved. They were big attractions. A bitter fight ensued and the boys walked out into a world that seemed in conspiracy against contract busters. The other two finally gave in, but Bing had Dixie to encourage him, to fight shoulder to shoulder with him and defy the world to hurt them. But no song came to his rescue and they got poorer and poorer.

At length they realized their fight was hopeless, but rather than give in to what they both felt was injustice, they moved to New York instead of surrendering. The fates were with them again—or so it seemed. Another song came along, another song with one of the weirdly symbolical titles that seemed to haunt Bing's life. This time it was his plea to the Fates for—just one more chance. One more chance to prove he had what the world wanted—that inimitable voice.

Both he and Dixie were overjoyed when he got his chance on the air. For days he rehearsed and kept his fingers crossed. They were awfully broke and that job meant everything to them.

The morning the broadcast was to go on the air Bing woke into a gloriously happy day—flooded with sunlight and the love of Dixie—but he couldn't swallow! The singer's Nemesis, a sore throat, had him collared. Frantically, he begged the station to let him off that night—he couldn't even croak—but not to let him out entirely. They understood sore throats and they liked Bing so they reluctantly put in a substitute.

● THE NEXT day the throat was worse. The Crosbys were really worried. Nationwide hook-ups don't wait indefinitely for comparatively new singers to get well. It costs too many thousands of dollars to be sentimental about those things.... This time it was Dixie who pleaded for just one more chance. She went to the station, realizing it was no time to bother with telephones or wires.

"Sorry, Mrs. Crosby, but I don't see how we can hold it up again."

"But Bing will be better tomorrow! I know he will! And, well, frankly—we need the money pretty badly right now. Just give us one more chance!"

"I don't see how—" he began, and then he saw the look in her eyes—and Dixie has high-voltage lamps, "—well, what does the doctor say about his throat?"

Dixie shook her head. "There isn't any doctor. I take care of this family!"

"Well, Doctor," he smiled, "will the patient be ready to sing tomorrow night—without fail?"

Dixie nodded solemnly, "Without fail!"

While Dixie sprayed her husband's throat that night she was singing her own version

Bing Crosby's Song of Love

of a song that was to sweep the continent the next night.

"You've one more chance, to prove—" she smiled,
—it's me alone you care for,
Each night you'll say a little pray'r for—
Just one more chance...."

PLEASE

*Please, lend your lit-tle ear to me, please
Lend a ray of cheer to my pleas
Tell me that you love me too.
Please let me hold you tight in my arms,
I could find de-light in your charms,
Ev'ry night my whole life through—*

"Ladies and Gentlemen — The Big Broadcast of 1932'— presenting for the first time on the screen such celebrities of the air as Kate Smith, Burns and Allen, The Mills Brothers, Bing Crosby...." That's really as much of the advertising matter that went out from the Paramount Studios in Hollywood as we have to read. Bing had had his chance ... and where he'd enchanted hundreds at the Grove, he'd now enthralled millions on the air. And the millions clamoured to see their idol.

Bing and Dixie came back to Hollywood victorious—but worried. Bing was a singer, not an actor. He wanted to sing in front of the camera, but he hated mugging. And they told him he'd have to act. To Bing that meant mugging.

Again his featured song seemed titled to exactly fit his mental state. He spent weeks going around the studio with a worried expression, saying "Please!" to executives, directors, everybody. Not, of course, that he wandered into the august precincts of Mr. Cohen's office warbling, "Please lend your little ears to my pleas." That would have been *lese-majesty*, or something, and most embarrassing.

But he did go to Frank Tuttle, the director, and beg him not to put him into any spots where he'd have to try to act. He swore he couldn't. He swore he didn't have the looks....

● OBLIGINGLY, THE STUDIO cut down his "acting" scenes to the minimum story requirements. And in fear and trembling, Bing went through them with no thought of technique. When the picture was finished, Bing was ready to go back to New York and the mike. He was sure he was a flop and kept telling Dixie so. When his option was taken up, he was the most surprised man in Hollywood. But Dixie ... well, that was another story.

"Of course I'm not surprised, honey! I figured you'd click all along," she giggled, "what do you think I married you for?"

"Well, gosh! Why not tell a guy!"

"You wouldn't have believed it.... But you will go through with it, won't you?"

"I don't know. It's all sort of surprising."

"It was Dixie's turn to play up the musical comedy motif by slipping her arms around his shoulders and singing—

"Please, lend your little ears to my pleas"—

LOVE IN BLOOM

*"Can it be the trees that fill the breeze
With rare and magic perfume?
Oh, no, it is-n't the trees, It's Love in bloom!"*

He was pacing up and down the corridor at the hospital. He was pale, and the palms of his hands were damp. He paused in his nervous pacing back and forth to look out the window. After all, he kept telling himself, she's got the best doctor that money can buy. Everything'll be all right. Don't get into a sweat. This sort of thing happens every day. But—oh, well, she's such a sweet kid! She's always stuck around with me, thought of me first in everything. She's been swell. And then, there's been Gary Evan—and now....

"Mr. Crosby...."

"Yeah?" he whirled about, "how is she? She okay?"

"Yes, indeed! And Mr. Crosby ... so are your two new baby boys!"

"Two of them!" Bing's mouth dropped open in amazement and then: "Gee, that's swell.... Can I see her now?"

"Yes, but just for a minute."

Dixie was holding on to his hand tightly as he sat by her bed. She turned her head toward him.

"Love me?"

"Gosh, honey, you know I do!"

"How's about a little song, then? A nice one?"

Bing stifled a sigh of relief. If she could talk that way, everything must be okay, just like the nurse said. He grinned at her as few people have ever seen the great Bing grin.

"Sure, kid, and I've got just the right number, too!"

He bent toward her ear and crooned to her in his softest voice....

*"Can it be the spring that seems to bring
The stars right into my room?
Oh, no, it is-n't the spring, it's Love in bloom!
My heart was a desert, you planted a seed,
And this is the flower, this hour of sweet fulfillment.
Is it all a dream, the joy supreme,
That came to us in the gloom?
You know it is-n't a dream,
It's Love in bloom...."*

They were pretty happy, those two youngsters, just then. But they had a lot more ahead of them, and two little kiddies to take care of.

SOON

*Soon, maybe not tomorrow but soon
There'll just be two of us
Soon you and I will borrow the moon
For just the two of us—*

● "THEY'RE COMING TO the post!" the announcer called on the radio.

"Mr. Crosby wanted on the set!" called the assistant director on Stage Nine.

With a groan Bing left the little portable radio in the corner and reluctantly went back to work. An assortment of props, grips and juicers stood around the radio and grinned. And well they might! One of Bing's horses had just lost the third race at Santa Anita. And he'd just paid off. It seemed as though that was all he ever did these days—pay off. He hadn't seen his colors win once and several men around the studio were figuring on getting the wife that new Ford next month if it kept up.

The split second the director called "Cut!" Bing was off the set like a bullet headed at break-neck speed for the radio. In sight of the men he slowed to a walk and dug into his trouser pocket. There was no need to hurry. The gang was grinning harder than ever.... The pay-off again!

Grimly he sang as he dished out the long green. He sang "Soon" with a meaning the song writer had never thought of and he sang it with a will.

He was called back to the set again just as the horses left the paddock for the fifth race. Disgruntled, he went to work, but when the camera turned he forgot everything but the song he was singing to Gail Patrick. At the end, Director Sutherland came to him, his face suffused with emotion, his hand out.

"That was swell, Bing! Congratulations!"

"Oh!—uh, thanks, Eddie, thanks! But excuse me please just a second ... Zombie's in the fifth at Santa Anita and I want to find out...."

"Well, what the devil do you think I'm congratulating you for? ... Zombie won!"

Work was called off for the balance of the day.

WISHED ON THE MOON

*I wished on the moon for something I never knew
Wished on the moon for more than I ever knew
A sweeter rose, a softer sky, an April day....*

● THE BIG BROADCAST of 1935 was over, marking three years of work since he first went on the screen. He'd been lucky. He'd been very lucky—money, friends, Dixie and the three kids, a stable of his own with horses that were beginning to win for him. Yes, he thought as he settled down in the chair on the verandah of his Santa Fe rancho, he'd been lucky! The moon was out and the night-blooming jasmine was in the air. Dixie was at the piano.

He sighed contentedly.

The phone rang and he was called in. It was Ev calling from the studio to announce a new contract for a million a year and only one picture to make. When Ev was through, Larry got on the phone to tell him that he'd just gotten a cable from Ainstree to the effect that Zombie had won the Grand National Bing had no sooner hung up than the phone rang again. New York calling. The National Broadcasting outfit had a proposition if he'd only go back on the air once a month; they'd erect a special studio for him, a new portable one so he could broadcast wherever he was with no more inconvenience than lighting a cigarette; they'd pay two million a year.

Not bad, thought Bing, as he hung up. Not bad! Of course, it was a shame to have to go to New York on such a swell night but the big new Boeing down back of the paddock would make it in a few hours. He kissed Dixie good-bye and was off in a roar of motors.

They had the contracts at the airport for him to sign so he wouldn't lose time getting back home. They also had a wire for him from home—Dixie had presented

him with sextuplets. They'd broken the world's record—brought it back to the United States! The band was just breaking into the Star Spangled Banner when the earthquake hit. . . .

"Bing! . . . Bing! Wake up! You're snoring your head off!"

Bing shook the sleep out of his eyes and looked around. The moon had dropped back of the stables.

"Bing! Will you please wake up and go answer the phone? . . . It's Larry calling from the studio."

"Oh, yeah!" he brightened visibly and muttered vaguely, "Sure, the new million dollar contract. . . ."

"Say, Bing," said Larry over the phone, "sorry to disturb you so soon, but you've got to be back in Hollywood the first thing tomorrow."

"New contract, Larry?" asked Bing, still half asleep.

"New contract, Hell!—re-takes on the 'Big Broadcast.'"

Bing hung up. He drooped off to bed. As he opened the window he glanced up at the moon.

"Oh, phooey!" he grunted.

THEY ALL WANT to steal my husband!
says MRS. CROSBY

You'd like to be a crooner's wife?
Not with a thousand dizzy dames
flitting around your fireside!

by WHITNEY WILLIAMS

THE SCENE OPENS in the Crosby hotel suite in New York. Dixie Lee, girlish and slender and clad in light blue pajamas, is lying at her ease on a satin-upholstered chaise longue, turning the pages of a fashion magazine. The telephone tinkles.

"Hello," comes a dulcet voice over the wire. "I would like to talk with Mrs. Crosby."

"This is Mrs. Crosby. Who's speaking, please?"

"It doesn't matter, dearie" . . . the voice fairly drips with honey, now . . . "I just want to tell you that I'm going to take your husband away from you, so watch out. Good-bye."

With a sigh, Dixie hangs up the French receiver. Nothing new is this for the beautiful blonde spouse of the screen's most famous crooning star. She must pay the penalty for being wedded to Bing Crosby!

So you'd love to be a crooner's wife . . . Ladies, you don't know the half of it . . . if you chance to be among those millions who hold this thought. Even in your wildest dreams you couldn't possibly conjure up what you'd be letting yourselves in for if you might realize this ambition. Only the "better-half" of a popular crooner can understand fully the grief such a position entails . . . and she doesn't like to dwell upon it too freely.

● THIS IS A MOST unusual case, you say. Granted it is . . . but still it happened to Dixie when she and Bing visited the eastern metropolis last summer. That particular experience never occurred before . . . but others just as trying and just as alarming have dogged her footsteps almost from the moment she became Mrs. Bing Crosby.

There was the time Bing was making a personal appearance tour in the east. Dixie smiles when she narrates this episode, but how many wives are there who would accept the circumstances with the philosophical calm that Dixie views such incidents!

"We had been out for dinner," Dixie twinkled, "and when we returned to the theatre we went directly to the dressing room.

"Bing went in first, to switch on the light. But just as he reached for the switch a girl jumped from out of the darkness and threw her arms around his neck, before he knew what was happening.

● "IF YOU COULD have seen Bing's face! It was a study in embarrassment and consternation. By this time, of course, he had touched the switch and flooded the room with light. Before she could say a word, Bing shooed the girl out of the room and dropped into a chair, throwing me an appealing look. I couldn't help but scream with laughter."

"On another occasion, we were returning home from the east. When the waiter brought our luncheon, not only the waiter entered the room but two attractive girls dressed in the heights of fashion scurried in after him. They insisted upon remaining for a while and talking, demanding Bing's autograph and picture and also that he sing for them.

"On the same train, we heard a woman cry 'Fire,' out in the companionway. Without thinking, I opened the door . . . and there stood a smiling blonde-headed girl, pretty as a picture, who pushed her way past me and rushed over to Bing."

Ladies . . . could you take it?

● ARRIVING HOME, a short time later Dixie heard Bing's car enter the driveway and went out to greet him. Before she reached the door, however, she heard a commotion outside and then a girl's voice raised in pleading.

The sight that met her eyes was indeed a strange spectacle, one which would have filled the average wife with strange misgivings. There was Bing backing away from the car, while a girl stood up in the rumble seat with arms out-stretched, begging that Bing lift her down!

"I just had to meet Bing," the girl told Dixie, hysterically, when the latter joined her husband, "so I hid in the rumble seat when he parked his car on the Boulevard and here I am. Please, Mrs. Crosby, don't send me away without at least his autograph. The girls back in Chicago would never forgive me if I came home and said I had met Bing and then didn't get his autograph."

"One night, the

Above, Dixie Lee as you see her in pictures, quite different from the rôle she plays as Mrs. Crosby, keeper of the crooner. Lower photo shows the Crosbys at a preview

They All Want to Steal My Husband

telephone rang and Bing answered." Another smile touched Dixie's features as she recalled this event. "It was New York and the party on the other end, a girl who said she was just eighteen, implored Bing to write to her, and to croon to her over the phone. She said a friend in Hollywood had sent his number to her and she was spending her savings of three months just to call him.

"In New York especially people call up and ask that Bing croon over the telephone. Here at home, very few strangers can get our number, but in the east it's easy enough, after they learn where Bing is stopping.

● "MANY AND MANY a time, girls and women of all ages call up just to talk, for no purpose other than to hear Bing's voice. While we're traveling, we always leave word with the switchboard operator at the hotel that we're not to be called ... but they put people through, anyway. Sometimes pleas are made for loans or gifts of money, often salesmen are on the wire, but for the most part the calls are from Bing's women fans.

Bing Crosby

"I remember one time when some girls claiming to be members of a certain sorority at one of the eastern colleges called me, while we were staying in New York, and insisted that I allow Bing to visit their house and sing for them. For some reason, they had gathered that I wouldn't allow Bing out of my sight, and one of them criticised me severely for such 'high-handed tactics,' as she termed it, in dealing with my husband."

What would YOU do under similar circumstances?

"Frequently, girls come to our door and ask to see Bing. It isn't at all unusual for a dozen cars a day to drive up in front of the house, bearing license plates of any one of the forty-eight states, and for two or three or even four girls and women to ring the bell and either ask politely or demand that Bing show himself. Once, when I answered the bell myself, a middle-aged lady told me I was deliberately ruining Bing because I was married to him!"

● DIXIE SHOOK her head almost sadly, as she dwelled upon this injustice. How many of you and you and you could have restrained yourselves from retorting in kind, instead of replying to the accusation with a gentle smile?

"One night last summer, while we were strolling up Broadway, a group of perhaps ten or twelve girls suddenly surrounded Bing. Not only did they want his autograph but some hugged and tried to kiss him. It was like bedlam let loose. In a second I was shoved to the outside of the circle and nearly landed in the gutter. When Bing finally rejoined me he looked like he had just been through a tornado."

So you'd like to be a crooner's wife!

Hollywood Spotlights

Bing Crosby's Color Madness

IT WAS AT A SUNDAY polo game in Hollywood. Gorgeously-gowned women and immaculately-garbed men were viewing the event from their exclusive vantage point.

Suddenly all eyes were drawn from the field toward the doorway through which a remarkable figure was entering. He was known to most of them; in fact, he would be known around the world wherever movies are shown. He had a string of horses at Santa Anita and Aunt Kitty (his one winner of the season) came home at the last minute. But even a horse race or a polo game couldn't compete for a moment with his array of clothing, described as follows:

Trousers—tan.
Shirt—pink.
Coat—black with huge checks and wide stripes.
Necktie—a brown and purple mixture.
Hat—gray.

To the motion picture stars present, he attracted only a normal greeting.

It was just Bing Crosby.

● TO THE NON-THEATRICAL eyes in the group, this sartorial splendor was somewhat sensational, but such garbling of the color spectrum long ago ceased to attract attention from his friends and associates in and around Hollywood.

A filmland columnist has described Bing's favorite outfit as a canary yellow sweater, rose shirt and a Paisley scarf tucked beneath a navy blue suit.

He should have added an old, soft floppy gray cap and the picture would have been complete.

● WHY ON EARTH WOULD ANYONE persist in defying all the laws of color harmony with such clashing arrays of vivid hues? Well, let's ask Bing, himself.

"Because I like 'em!" Bing answers, promptly.

Bing Crosby is a crooner, but no clothes horse! He's wearing one of his favorite outfits in this photo with his son, Gary

After all, it's very simple, isn't it? But there is a much deeper reason than that, which we'll find shortly.

Bing's simple and direct answer provides the clew to one reason for his eccentricities in dress. He is, shall we say, slightly bullheaded about this matter of clothes. Even his tailor, one of the best in Hollywood, has learned that any disagreement with Bing's exceptional ideas on clothes is just so much wasted breath.

Out at Toluca Lake, which Bing, Dixie Lee and their three youngsters call home, a solicitous negro servant takes care of Bing's personal effects, keeps them in shape and in order, but, do you think Bing would let him lay out his clothes or help him dress? Not on your life!

"I always have been able to get dressed without help, and I guess I can yet." Bing settles the argument.

Once in a while, Dixie puts in a word when he starts toward the doorway wearing one brown sock and one blue one, but otherwise Bing is the final word in his sartorial schemes. At the studio before the cameras, the studio costume department assumes responsibility for the question of clothes, and fortunately Bing hasn't gone in for Technicolor yet.

This "because I like it" theory also partially explains another Crosby penchant. Bing likes old, comfortable clothes—an easy pair of brown or gray pants, just a little baggy preferably; a turtle-neck sweater (sometimes two,) usually yellow; a gray or tan coat, ordinarily of a huge-check design, and a nondescript, comfortable cap of some kind.

● THIS IS BING CROSBY as his friends know him around the studio when not before a camera, before the microphone as a radio entertainer, and elsewhere around the film colony.

Bing's penchant for big-check designs overrides his physical make-up. Bing is chunkily built, very broad through the shoulders. He is only five-feet-ten and weighs 175 pounds, which should cause any tailor to suggest slenderizing longitudinal stripes. But not to Bing! He likes checks, and checks it is.

"Don't they have stripes running up and down, as well as across." Such is Bing's

PUTTERING AROUND » » » ANITA LOUISE & HELEN MACK

Step right up ladies—a bucket full of golf balls for each!

Who's first? Look out, Anita and Helen, this isn't all sheer fun!

Aha—we told you so! Linament and hot packs for the arms tonight

Bing Crosby's Color Madness

Bing Crosby's checkered clothes were notorious at the races! Here he is shown at Santa Anita track, with his favorite horse

naive retort, to which his tailors have not succeeded in thinking up a good answer.

There is another side to Bing's yen for rough, comfortable, he-man clothes. Literally, tens of thousands of romance-starved maidens throughout the world have fallen in love with that husky-throated crooner sending out lullabies from the screen or a radio loud speaker. Every week, thousand of billet-doux pile into the Crosby dressing rooms at Paramount. While Bing appreciates the compliment, in a way, it also gets under his skin.

"You would think I'm some sort of a patent-leather haired Don Juan, or something," the crooner half complains. Whatever may be your conception of Bing Crosby, be assured he is no second Valentino. He is just an ordinary, very human, Spokane, Washington, boy, with a tricky voice that carried him to fame and fortune.

Some of Bing's friends believe his baggy old clothes habit is more the expression of a secret complex, an expression of he-man revolt against the unceasing barrage of mash notes. Bing insists he just likes to be comfortable and can't see any reason for not being.

But he can't explain away so easily this matter of getting on one brown sock and one blue one that Dixie caught before he escaped through the front door.

"Well, they're the same weight and both silk and—they look alike," Bing argued in his rather bashful manner.

● HAVE YOU GUESSED THE ANSWER? Bing is an unfortunate victim of that peculiar ailment, achromatopsia. In other words, he is completely color blind.

This little fact begins to throw much light upon the Crosby habit of gay, even though clashing, color schemes.

"I wear 'em because I like them!" Bing says.

The wise men of medicine calmly nod their heads in approval. Bing is right. He undoubtedly does get a sense of optical satisfaction from the hodge-podge of vivid colors he assembles because they do not look the same to him as they do to you and me, most of whom have a normal perception of, at least, the seven pure colors in the solar spectrum. Between the red end and the opposite violet end of the spectrum are millions of different tones of color, medical history recording one pair of eyes that could distinguish and describe 14,220 different shades.

Medical men tell us one out of five men and one out of twenty women are, at least partially, color blind. Some fail to distinguish only certain colors. Others, like Bing, have an optical system that completely distorts all colors. In fact, he may look at the same color at two different times and get two different color reactions.

So don't blame Bing if a yellow sweater, a pink shirt, a brown and purple tie, tan pants and a gray cap look appealing to him. Probably your carefully matched ensemble is shocking to his achromatopsic eyes. Anyway, he was born that way and can't do anything about it. Medical science thinks color blindness may result from some abnormal internal pressure on the optic nerve.

● ONE OF BING'S BROTHERS, Everett, also is color blind, but Everett claims he is better than Bing because he can, at least, match things even if he can't tell just what colors he's matching. Again medical men nod. This is a fact in some cases of color blindness, but a rare hour of entertainment is in store for anyone who can get Bing and Everett to arguing their respective abilities as color selectors.

Bing was seated at a table, poring over a manuscript. Abstractly, he was answering questions about the color of clothes and other things about the room, with occasional good guesses.

"What color is that pencil you're writing with?" we asked.

Obviously, he was taken by surprise and closely inspected the pencil with a sheepish smile:

"Aw, let's skip it!" The pencil was red as barn paint.

Bing's golf partners have remarked that he never bothers to pick up those little red, yellow and green wooden tees that you stick in the ground. It might interest them to learn that, after Bing sticks one in the grass, he couldn't find it again to save his soul without getting down and feeling around for it.

● BING ISN'T PARTICULARLY sensitive about his color troubles, but he doesn't always see the humorous side of it. However, he will never forget the first outfit of clothing he bought all by himself with his own money.

He returned home with what he thought was a swell blue serge suit and a new pair of brown shoes, only to learn that he had acquired a bright purple outfit with a pair of yellow shoes.

"I didn't have money enough to buy any more, so I had to wear them," he recalls, with a faint glimmer of a smile. "Anyway, they looked all right to me."

So, maybe, there is the origin of his laconic explanation:

"I wear them because I like them." And, after all, he's the one who has to wear them, isn't he?

Crosby Saves Chinese Babies!

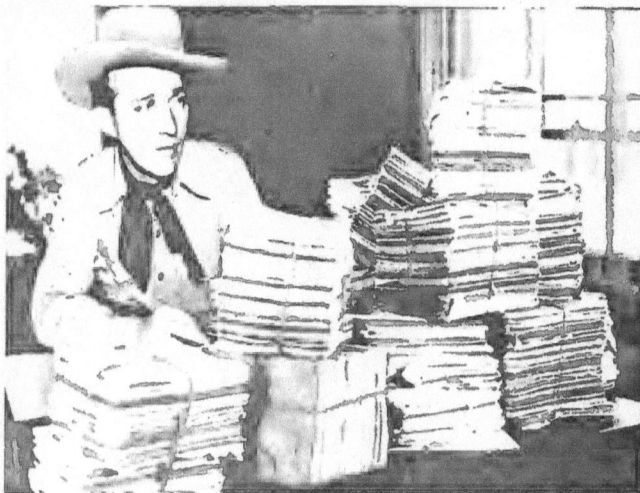

Bing Crosby surveys some fan mail the stamps from which are saved and sent to China to save the lives of Chinese girl babies

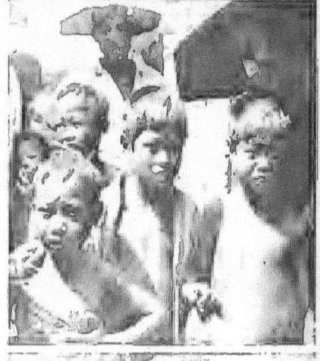

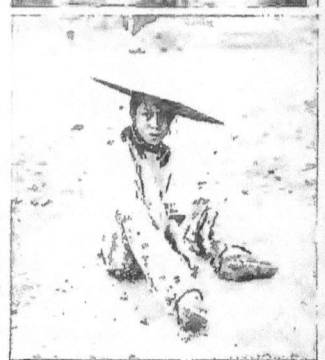

It is groups such as the one above that are given life through the many fans who write Bing Crosby letters. Lower photo shows one little Chinese girl who might never have known life except for the stamps off fan mail

THAT TITLE ISN'T entirely true. It's Bing's fans who save the lives of Chinese baby girls. They don't know it, of course, but they've saved hundreds of tiny lives over the last six years. Bing receives on the average of 15,000 fan letters a week. Each letter helps save a new-born girl from being drowned in a river or left for the rats to devour.

Yesterday, for instance, you may have written Bing a note of appreciation. That makes you a life saver. And if you are a regular correspondent you may be responsible for some of the faces that look at you from this page.

In China, in those remote sections where life is bitterly hard, a baby girl is absolutely valueless. She is never wanted. No sooner is she born than her parents push the little head under water, or leave her for the rats to finish. Better that than to let her starve. And precious rice cannot be wasted on a sex that isn't helpful in the struggle of life.

But for a hundred years the Jesuits have had an organization in China fighting this social curse. Known as The Association of the Holy Childhood, they have salvaged a countless number of these unwanted baby girls. The association buys them from their parents, feeds and keeps them in their various missions scattered throughout China.

The way they finance this humanitarian project sounds ridiculous. But remember, this is China. Human life may be cheap but even peasants have aesthetic souls. They love beauty, and beauty, to them, is largely a question of color. So the association buys these new born babies with stamps.

It makes no difference that the stamps have been used. They can be used again to decorate screens and the various bagatelles that peasants sometimes make and sell. The stamps, at least, have value—the poor infants none.

In the United States, the Mission Stamp Bureau, Mount St. Michael's, Spokane, Wash., collects the stamps in this part of the world to forward to China. Bing has been sending it all of his stamps for six years. He has a staff that handles his letters, clips off the stamps and sends them on. The average has been fifteen thousand a week.

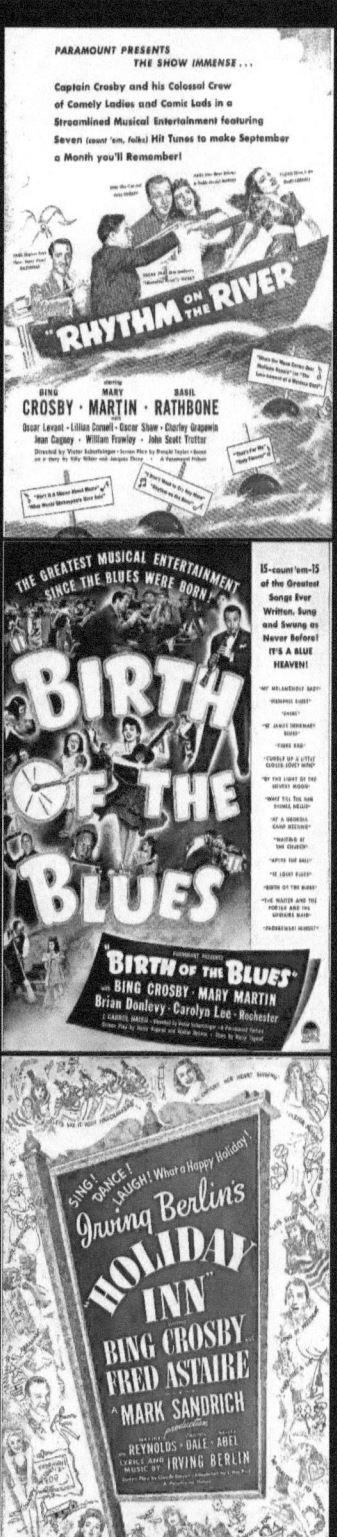

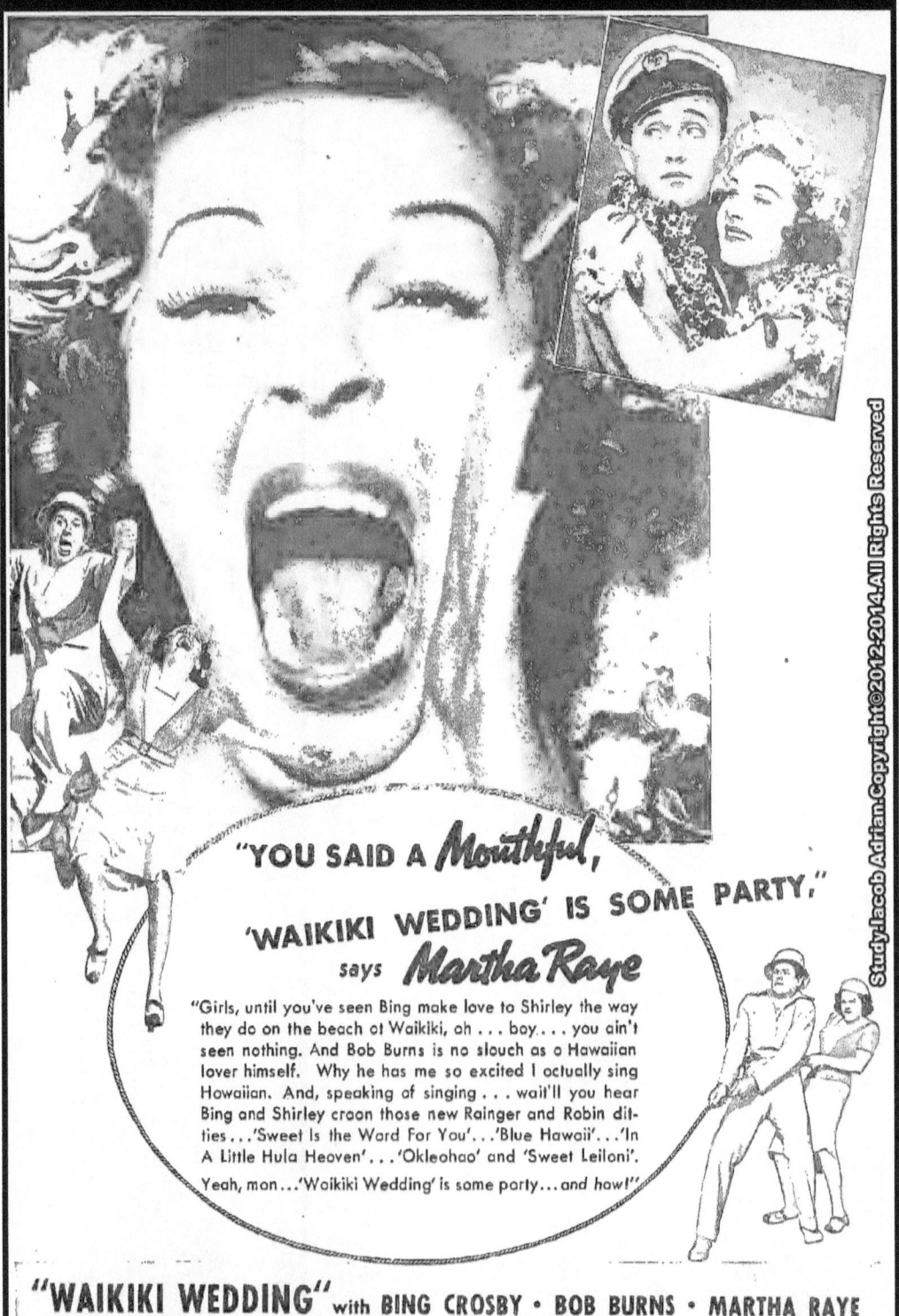

BING NEVER LETS YOU DOWN

Pals, crooners, stockholders, relatives—all pay a happy allegiance to the beneficent Bing whose heart is as big as his fortune

WHEN Bing Crosby and Al Rinker cruised down to Los Angeles from Spokane in a battered Ford at the start of Bing's career, the two boys sought out Everett Crosby, Bing's big brother.

"We've got something on the ball," said Bing and Al. "You're now our manager."

Everett heard the boys sing, saw them put on their act. Everett, when not selling trucks, was a man-about-town. He'd been to the night spots and knew all the orchestra leaders. Among them was Harry Owens.

"Give 'em a chance!" Everett pleaded. "I can't let 'em down."

Harry Owens gave them a chance and made history. He told Bing:

"You both can sing. You've got a style. You're hired."

Young Harry L. Crosby, fresh from Gonzaga University, got his biggest thrill out of those words. He and Al sang. With the help of Harry Owens, they graduated to Fanchon and Marco. Counselled by the same Owens, they landed with Paul Whiteman, and accumulated Harry Barris, making the famous trio.

Time passes to find Bing the man of many interests, involved in producing his own pictures, building a race track, running golf contests, singing over the radio, editing a magazine, raising race horses, and heading a corporation bearing his name. He is in Honolulu enjoying a vacation with his wife,

Bing and Mary Carlisle team together for the second time to turn out Paramount's hilarious comedy Double or Nothing

Bing Never Lets You Down

Dixie Lee Crosby. He is seated at a table, listening to Harry Owens' orchestra play. When Harry finishes he joins Bing.

"I've got to have a song for my next picture, *Waikiki Wedding,*" Bing says. Got anything up your sleeve?"

"Sure," says Harry. "It's *Sweet Leilani*. I wrote it for my youngster."

BING hears the song played by Owens' Royal Hawaiians, has Harry give him a copy, sends it back to the film capital with the notation written across the front page in the Crosby hand:

"This could be the love song he first sings to the girl, which becomes her love theme."

That's what happened. *Sweet Leilani* proved to be one of the most popular pieces in America and Harry Owens is in the top ranks as a song writer.

WHEN Bing and his crooning first really caught on while he was at the Cocoanut Grove at the Ambassador Hotel in Los Angeles, Bing was crooning ballads written for him by Arthur Johnston. Bing, being modest, knew that the words and music had a lot to do with the rise of his star.

So, when he began making motion pictures, he made sure that Johnston was hired to put tunes into them. All went well for a while. Then Johnston snapped under the strain.

First he lost his job at Paramount. Then he went into a hospital. He was there for months. Keeping a watchful eye on his progress was one Crosby. Finally, Johnston emerged. Hollywood, as usual, made a speech like this:

"Johnston's through. He's lost his spark. Nobody can go through what he did and have anything left."

Bing didn't feel that way. He asked Paramount to hire Johnston and got nowhere. He asked other studios to do the same and got the same place. He just bided his time until he invested his own money in *Pennies From Heaven*. Then he hollered:

"Get Arthur Johnston!"

Perhaps it was gratitude, perhaps it was the inspiration of having a friend but, whatever it was, Johnston delivered. It was Johnston's music in *Pennies From Heaven*.

A LITTLE over a year ago San Diego wanted a fair g r o u n d s. The county made a deal with the WPA and agreed to put up a certain amount of money. The county couldn't deliver as specified. Bing, rancher, is one of the most influential country gentlemen in those parts.

A group of commissioners waited on him one day.

"If you will lease the fair grounds track for ten years, giving us $100,000 and a percentage," they told him, "we'll be able to have a fair grounds."

"That sounds very nice to me," replied Bing. Whereupon he formed a company, sold stock to about 3,000 people, some of the group farmers and ranchers in San Diego County, others employed in motion pictures.

"But," Bing added, as he went into one of the oddest stock promotions in history, "although I want these people to benefit from the racing and get dividends on their stock, they mustn't take any risk. I don't want them holding the bag if the deal falls through."

The result of this thought was that the farmers and the picture people put their money in the stock all right. But the money was held in escrow and Bing Crosby actually put up the money—every cent of it himself—until the plant was ready to operate. When it got under way he withdrew his money, released that of the stockholders for operations expense.

CROSBY is technically known as a "pushover." Not only do thin faced bums get their hands into his pockets with such regularity that there has been the suggestion of getting a strong-arm man to carry his money for him and reject the appeals of both himself and the bums, but bigger things have been done.

Bing Crosby, Inc., is a very serious organization, designed simply to keep Bing's brakes properly lined. He must be stopped.

People with Rube Goldberg inventions, men with golf courses which would pay a profit if Bing would only invest $10,000, idiots with schemes for raising fur bearing animals, slickers with highly polished gold bricks in their pockets, tell Bing stories. Bing listens. Then, without thought of any profits accruing to himself, but with the motive that if he helps somebody'll be made happy, he says:

"Yes!"

Whereupon, he, as president of Bing Crosby, Inc., is summoned before the Board of Directors, consisting of himself, his brother Harry, his brother Larry, his father Harry, Sr., and John O'Melveny, the Crosby lawyer. A vote

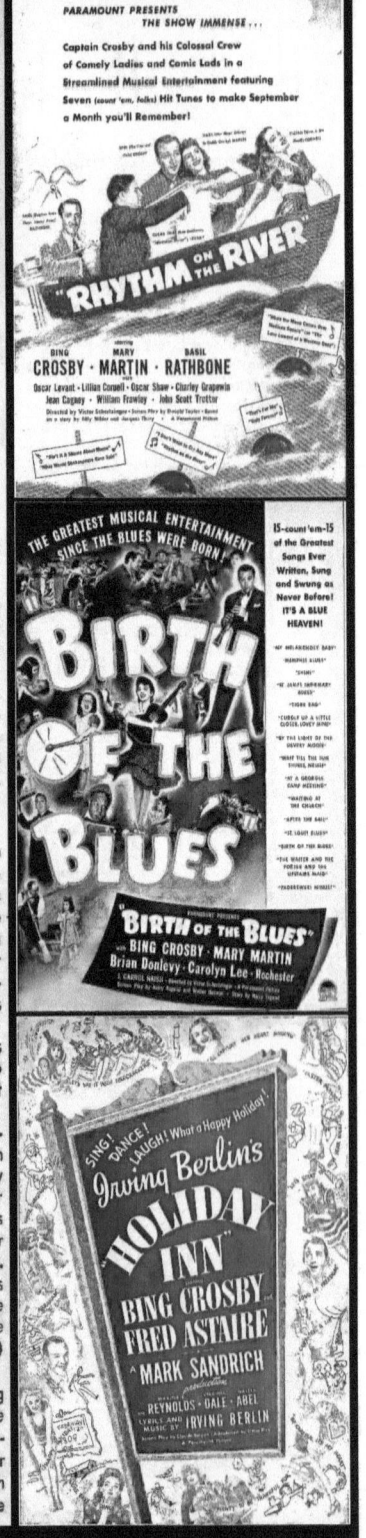

is taken after the merits of the proposition are considered and the talley inevitably is:

"One vote affirmative. Four votes NO!"

BOB BURNS was singing a sad song in the ears of Bing at Santa Anita race track some meetings ago. Bob, it seems, had talent, but nobody appreciated it.

"Change your act and go to New York City," Bing advised.

Bob did. But Bing felt that his obligation didn't cease when Burns began to click. He put the Arkansan into *Rhythm on the Range* with Martha Raye, whom he also thought had possibilities. He put Burns on the Kraft show.

Producers have been accused of nepotism which, in many cases, has resulted in the hiring of competent relatives. When Bing came to Los Angeles, Everett, his brother, went to bat for him. Everett is a fancy dresser, loves the good old bright lights, knows the night spots. Bing stays at home. But the business relationship goes on.

In spite of this social disagreement, the men are fond of each other, and Everett does a swell job. When the corporation was started, there was a need for an auditor, a secretary and treasurer. Bing sent for Dad Crosby, who held such a job in Spokane. When a publicity and advertising spot opened, Bing demanded and got Larry, another brother, qualified for the position by years of publicity and advertising work.

THEN there's Leo Lynn, Spokane friend who stands in for Bing, and who, under Bing's supervision, who does bits in Bing's and other pictures—a string of fighters who work in Crosby pictures when not fighting—and scores of others who have felt and are feeling the kindly Bing's helping hand.

Not very long ago the Crosby Board of Directors was in a dither. Bing's radio contract was coming up. Bing's motion picture contract was coming up. Hours had been appointed and set aside for deliberations which had at stake a cool million dollars.

Came a telephone call from the ranch, more than a hundred miles from Hollywood.

Bing grabbed his hat.

"I'm going to the ranch," he announced.

"You can't do that!" said four voices.

"The heck I can't," said Bing. "Listen—Bon Eva was my first horse. She's just foaled. I've got to see how she and the colt are doing."

And he went.

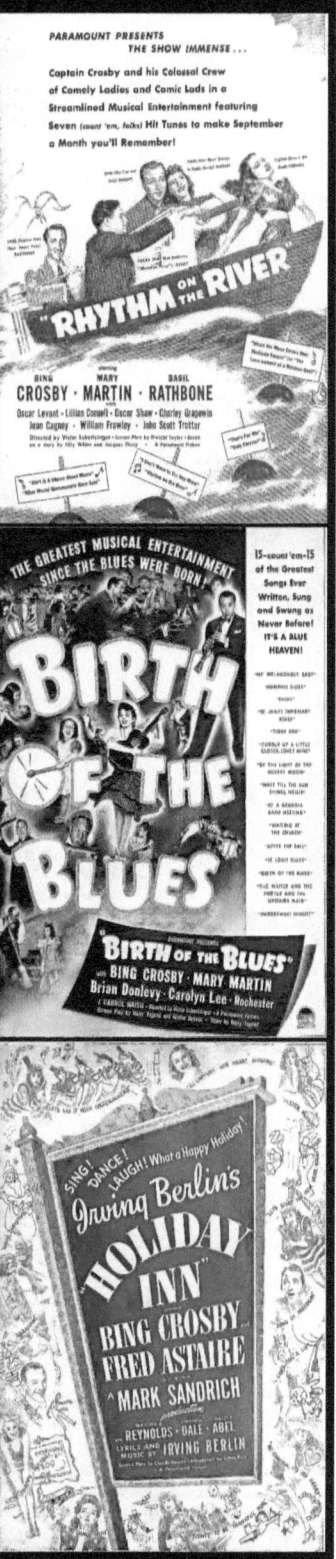

This is the house at 508 Sharp Ave., Spokane, Washington, where Bing grew up

Working on the way to Gonzaga University in Spokane to receive his honorary degree of Doctor of Philosophy in Music

This is where Bing made his professional debut, singing and playing the drums

Dr. Crosby Takes a Bow

Bing was not a shining light in school, but he has the right to put Ph. D. after his name and to insist upon being called "Doctor" if he likes

By CHARLES DARNTON

Neither is he wrapped in stately robes of learning nor solemnized in scholastic frock coat and plug hat. Indeed, he swings freely into view sporting a gray sack suit, a blue shirt unbuttoned at the collar, and a rakish cap cocked jauntily over one ear—possibly his ear for music.

This is oddly fitting, since Dr. Harry Lillis Crosby, accompanied by the degree of doctor of philosophy conferred upon him by Gonzaga University, is taking the air in Central Park, or rather a Hollywood replica of that portion of it allocated to the resounding zoo.

Now Dr. Crosby pauses and leans contemplatively over the rail of a huge tank wherein a trained seal is diving for small pieces of fish and a necessarily large piece of Andy Devine. The good doctor's grave air, as well it may be, is that of a man who presently is to go and take a jump in the lake.

For the occasion, be it known, is dedicated to a scene in *Dr. Rhythm*. The moment is devoted to the water cure of a lamentable hang-over suffered, or stimulated, by the rashly immersed Mr. Devine.

As he weighs the consequences, roughly estimated at three hundred pounds, Dr. Crosby shakes his head deploringly, then turns briskly to pace the cage-walk, monkeys chattering, lions roaring into his sensitive ears.

Noting his abrupt action, you put it down to the Bing in him, lightly balanced nerves quickening the restiveness of genius. Your problem is to get him to hold still long enough to be interviewed. You despair at the prospect, all the more as his glinting steel-blue eyes sight you from afar and something in them plainly says, "So that's the guy who's come to give me the works."

But, after further deliberation and long-distance scrutiny, the resigned phi-

When Bing left Spokane all he had was an extra shirt and some drums. But he came back with a water wagon for the team

At brother Ted's home, Ted, Bing and Douglas Dyckman. Seated, Bing's mother, Mrs. Ted, her children, and Bing's father

Bob Burns and Bing are initiated as members of The Round Table, breakfast club of Spokane's prominent business men

This brewery formerly was the pickle factory in which Bing washed bottles and sorted cucumbers after school hours

Bing couldn't miss accepting the honor paid him by his university. So he took his whole radio troupe to Spokane with him

Mayor Frank Sutherlin handed over the key to the city, made Bing Mayor for the day, and let Bob Burns be Chief-of-Police

losopher genially approaches and generously gives you, with his good right hand, a nice dry set-chair, while he sits down with Spartan hardihood on a wooden bench still wet with the plumpish outline of the performing seal who all too recently has been sunning himself there.

Repressing your first eager impulse to ask Dr. Crosby to sing something, you respectfully inquire regarding his feelings as to his eminent doctorate.

"I feel it to be a great honor," is his simple reply.

Instantly you like him for it. In it is the sincerity of the man himself, the honesty which is part of him. Light as is the banter he so inimitably brings to his radio broadcasts, here is something not to be taken lightly. It is a big and an honorable reward come to him unforeseen and unsought, an accolade bestowed for meritorious service and character, a gift received with grateful appreciation of and loyalty to his university and its learned heads. He, in turn, has made himself a credit to it and to them not merely as a crooner of songs, but as actor, wit and Irish minstrel.

Irish? Yes. And this tells more than half of the story as you hear: "My mother's name was Harrigan, and dad's mother was Irish."

There's where his wit comes from, you confidently assume.

He smiles the best way, with his eyes. "I question whether I have wit of any appreciable dimension. But there has always been music in the family. My father and mother and grandparents all sang and played, though not professionally. But when there was a local performance of *The Mikado* or another of the Gilbert and Sullivan operettas in Tacoma or Spokane my people were sure to be in it. And there was music in our home from morning to night."

His innate modesty is evidenced in the absence of anything about himself, and when you attempt to bring him back to the effect upon him of his lofty degree he says no more than:

"I got a great boot out of it."

No doubt he now is getting the same "kick," but he casually side-steps this suggestion with:

"It was so unexpected that I am still trying to get used to it. I can hardly believe it, and I'm sure this is the case with everybody who knows me." You are set to wondering how his neighbors have taken it.

"They have, individually and collectively, been most congratulatory," he is grateful to say. "There has not been much talk about it, but I should say the best minds of Toluca Lake are of the opinion that I'm just a lucky guy."

Caught in the suburban spirit, you ask how his newly-won high estate has affected his golf game.

"I am afraid," he grins, "that being weighted down with honors has made me a little ponderous on the course. Although I manage to swing the old club clear of mental profundities, my stance is a bit on the heavy side."

Like the true golfer, Hollywood's crack player brings out his briar pipe and fills it. This is well, for smoking is prone to put him in the proper mood for setting forth his own philosophy, the philosophy of his great success.

"It has all been just luck," he insists. "This is the shameless truth. I never even thought of a career. Perhaps the only reason I hung around school till I was fifteen was that I [Continued on page 63]

 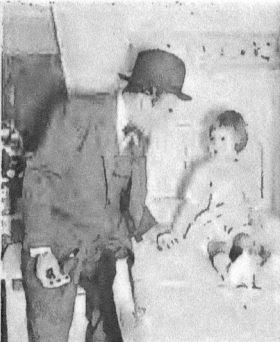

This is part of the crowd that overflowed the Armory when Bing staged a show and gave the proceeds to his alma mater

Here is Bing making a new friend on his tour of inspection through the Shriners' Hospital for Crippled Children

Receiving his honorary degree from Mon. Condon. Left, Father Perrault and Gonzaga's president, Father Leo J. Robinson

Dr. Crosby Takes a Bow

lived across the street. It was easy to go to. I never had gumption enough to go out after anything. It was pleasant, too, at the university. I didn't study for anything in particular. It just happened I was pretty good at languages" (note his flair for French in his radio *causerie*) "and that just about lets me out. Studying music was something that never even occurred to me, and if it had I'd probably have been too lazy to do anything about it. I'd sung around the house, as every kid does, but never dreamed of making singing mean more to me than fun. When I joined the band at school as drummer I was given an occasional song to sing simply because I was the only one in it who didn't have a mouthful of saxophone. It was wholly unconscious training. Later I thought I'd like to go into show business, but doing so was purely a matter of luck. I didn't think I could really sing, and I don't think so now. You could shut me up in a room over there," flinging out a hand, "with ten other fellows who could make a noise and, standing outside, you wouldn't be able to tell which one was me."

When you protest, he promptly challenges:

"Want to bet? I'll bet you anything you like. You can announce the contest now and let readers know how it came out in next month's magazine: Don't believe it? All right, I'll tell something that actually took place. After I'd been singing professionally for a long time I was in Boston and entered a blind contest. At the start there were twenty or thirty of us in it, but in the finals the number had been cut down to five. I was one of the five—and finished fifth. Floppo!"

Now what are you going to do with a man like that, a man famous the world over, a man whose home town has proudly found him out, yet a man who seemingly glories in earlier defeat? He is even more astonishing when he reveals:

"I can't play the piano. I can't even read music. With me it's all by ear. I have an ear for music—without which nobody could get anywhere. But it's a heritage. For generations it has been in the family, and finally it has come down to me. That's all there is to it. If you want the low-down on me, I've never worked for anything."

But you argue he must at some time have worked at something.

"Yes," he is bound to admit, "I once worked in a pickle factory. I worked there for two years. What doing? Sorting cucumbers. The place had changed when I went to see it on my recent visit to Spokane after the ceremony at Gonzaga. Yet it worked its old spell over me. With it was a new sense, a realization that it was there I had, unconsciously, first become aware of something beyond me, glimpsed a dawning vision of a vague though true art form. At last it broke in upon me that as a green youth I had not merely been sorting cucumbers, but choosing them for their symmetry and stringing them into an endless chain of emeralds full of pure beauty and potential indigestion."

As youth speaks in the melodic voice of this poet-philosopher, you press him for advice to the young. His mood changes to the practical with the regret:

"I wish I had studied music, built a better musical foundation. I just kidded around with it. But all that kids today have to do to get a musical education is listen to the radio, hear the finest orchestras and the greatest symphonies. Free of cost, they are given every opportunity to develop any gift for music they may have. I appreciate the benefit this may be to my three boys. At present the songs they like best are 'Sweet Leilani' and 'Buckaroo.' But as the twins are only three years old and the other boy four, it is still too early to judge of their possible lyric quality. There is no means of knowing whether they are ever to be singers. But already they have developed such tonal volume as to encourage me in the belief they may all one day become famous auctioneers."

Knocking the ashes out of his pipe, Dr. Crosby reminiscently adds:

"As a kid, my favorite song was 'When I Leave the World Behind.' What is it now? This is hard to say, as there are several songs I like very much, among them 'Smoke Gets in Your Eyes.' My chief interest is in singing. As an actor, I think I'm pretty bad. But in spite of this, Hollywood has been very good to me in the twelve years, on and off, I've been here. It is a vigorous, vital locality, with something for everyone who has anything to give it. Its outstanding characteristic is its sense of humor. It kids anybody who is too impressed with himself. But it pays him what he is worth—sometimes more. From the material point of view, considering the emolument of cinematic endeavor, it is not too much to say that the Hollywood honorarium ofttime approximates a fancy hunk of dough."

True enough. Yet you cannot believe that Dr. Crosby, kneading his own con-

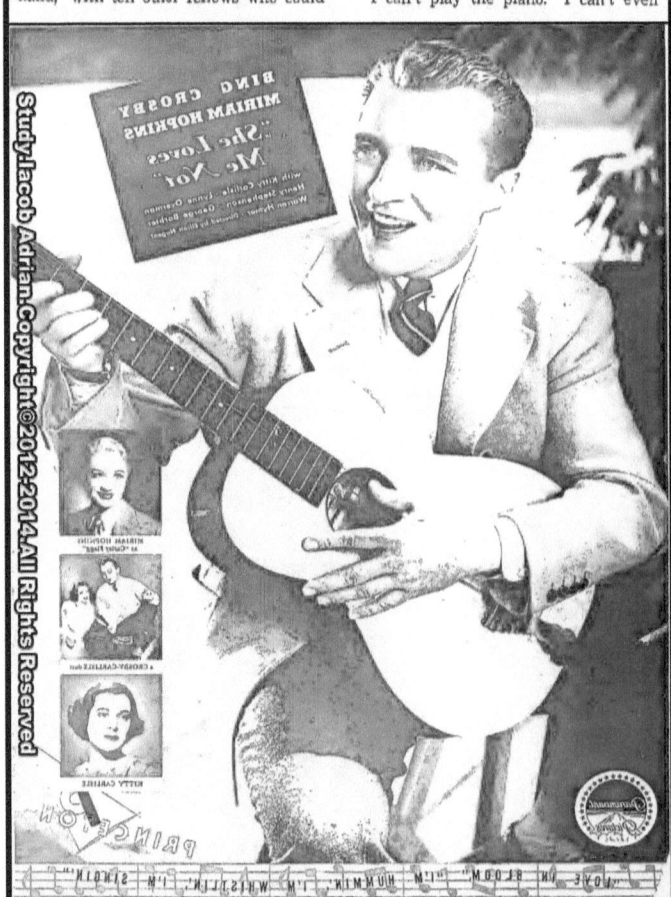

siderable lump, values money as the most precious thing in Hollywood life.

"By no means," is his emphatic reply. "Most valuable of all in Hollywood is its leisure. A man, and for that matter a woman, may enjoy it in the open. I myself like a good time. I'd rather make less money and have more fun. I can't see the benefit of working all the time. Not that I'm thinking of retiring. I can't retire because the government has got me by the tail. But if you keep everlastingly at it you're sure to regret it when you grow older. Maybe this is a selfish way of looking at it, but there are so many things to see, and I like travel. I've never missed anything I wanted to see, and I believe I would have seen the same things even if I hadn't got a break. Then there are so many things right at home. Circumstances permitting, I should say the perfect man is the one who loves home, family, work, and sport."

"I like horses and golf," he assures you. "Of my twenty-five horses twelve are racers. I get a lot of kick out of them and a little money—one has won nine thousand dollars. I wouldn't part with any of them for any price. But the other day out at my ranch I bet a racer to a work-horse owned by my friend and neighbor, the General. Now this would seem a foolish thing to do. But my horse always comes home—except in a race. This time the General and I were betting on a 'fixed' race, though he was not aware of the fact. To understand the somewhat unusual situation, you must know we are both enthusiastic gopher fanciers. His Mercury and my Pegasus are the two fleetest gophers in Southern California. We were betting horses on a hole-to-hole race. It was a cinch for Peg to win, as I had trained him on Waldorf salad, whereas Merc had been trained on new-mown alfalfa. I didn't want the General to lose his horse, and it was perfectly safe to let him win because I knew my horse would be sure to gallop back to his own stable the moment he found himself on a strange ranch. That was the set-up. But something had to be done about it to protect the General. So I took along a small portion of the Waldorfian provender in a perforated container, knowing a mere whiff of it would give Peg pause, thus getting him off to a poor start and causing him to lose the race. All I had to do was palm the salad and whisk it under Peg's nose as the starter—my hired man—yelled, 'One, two, three—go!' Taking a three-second smell of his favorite chow, Peg gave Merc such a big lead that he himself didn't have a chance. My horse? Oh, yes, he kept coming back home till the General got sick and tired of going after him and finally let him stay there. And as for a race of any nature, it has always been my philosophy ... Excuse me, please, I've got to go and fall in the water."

A moment later, Dr. Crosby, rendered perilously helpless by the Gargantuan clumsiness of Mr. Devine, is toppled over into the yawning tank. You watch his head disappear, yet do not stand affrighted, content to know it will rise triumphant to wear its new laurels.

In Defense of Laziness

He is one of the busiest young men in Hollywood but he does it with the minimum of effort, and won't even rise to defend himself against the charge of being too lazy to move

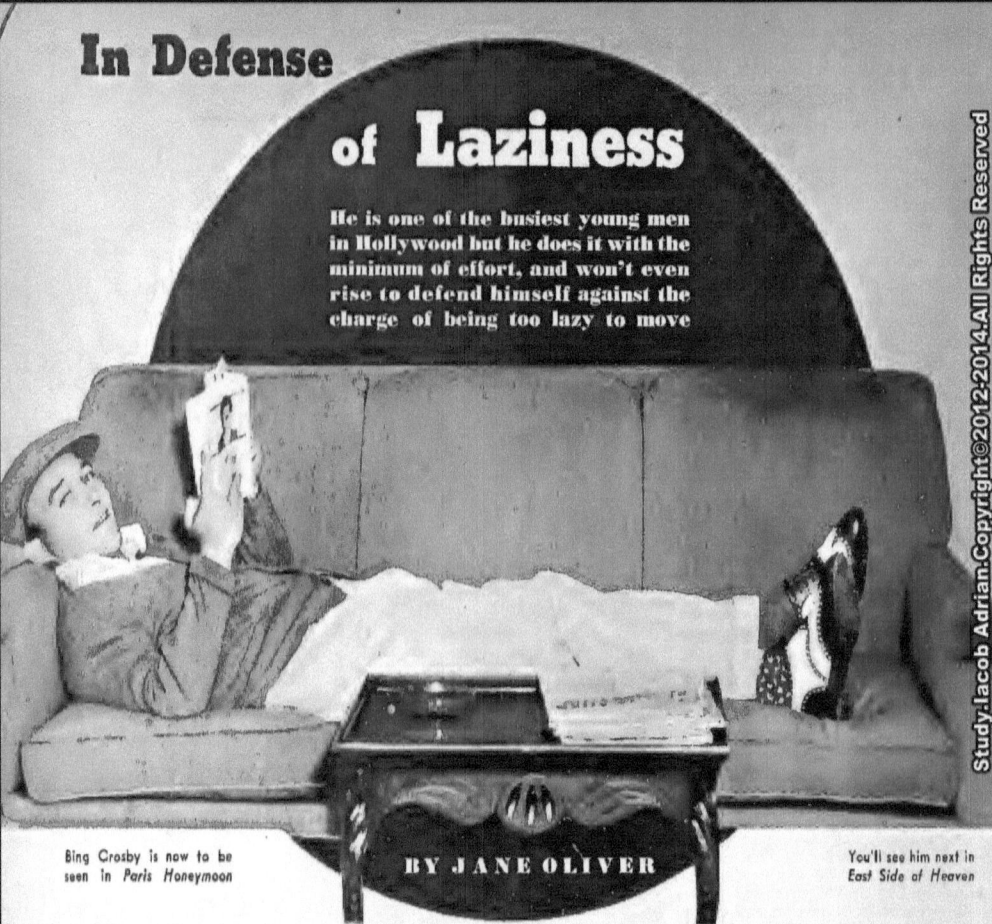

Bing Crosby is now to be seen in *Paris Honeymoon*

BY JANE OLIVER

You'll see him next in *East Side of Heaven*

There are those who earnestly maintain that the only reason Bing Crosby wears those awful colored cotton shirts that hang outside his trousers like an Egyptian flag at half-mast is because he's just too lazy to tuck a normal shirt tail in.

That, however, is base slander, according to Bing. It is merely a matter of intelligent conservation of energy.

"Let us consider the problem thoughtfully and with due logic," he proposed. "Ten seconds is the time it takes an average man to tuck his shirt tail inside his trousers. Say, he goes through the maneuver only once a day, that's three thousand, six hundred and fifty seconds or one whole hour a year. Further, say he starts the process when he is ten years old and continues it until death at seventy, that's sixty hours in a lifetime. Sixty hours is five days *and* nights. If he is an extra careful tucker-inner, using the twenty second method, that's ten days and nights. If he dresses for dinner, that's twenty. Imagine spending twenty days and nights out of a lifetime doing nothing but tucking a shirt tail in! I call that a criminal waste of human energy. Me, I don't believe in it."

Well, you'll have to admit that's one way of looking at it. And come to find out, Bing seems to have just as plausible a reputation for every single count on which he is charged with being the laziest guy in the world. Some of them are such pips you may find them handy next time you need an air-tight alibi.

There's the little matter of his wearing socks that never match, for instance. That's an established Crosby custom. Nine times out of ten, when you get a quick gander at his nether bones, you'll find one ankle wrapped in a fancy bit of Scotch plaid, and blue polkadots swarming all over the other. But it is not, as his harassed wife, Dixie, is wont to claim, because he grabs hit or miss in his sock drawer. Perish the thought!

"The explanation really is very simple," Bing countered. "In the first place, I'm on the color blind side, so how can I tell if they match? In the second place, mismatched socks are considered lucky 'round a race track, and lady, can I use a little luck there!"

Dixie obviously isn't taking the right attitude about the thing. And neither are his brothers, Larry and Everett, who handle the bulk of his business affairs, and who constantly are faced with getting him out of legal jams because he refuses to read a contract through. Nor Paramount, where it's a battle to get him to make more than a couple of pictures a year. Nor NBC where he refuses to rehearse his Kraft Music Hall program more than a couple of hours when other hour shows spend days at it.

No sir. They're all wrong. He isn't lazy in the technical sense of the word. It's just that they don't understand his philosophy about work.

"Every man must do so much work," he expounded. "The idea is to do it with a *minimum of effort*."

From all accounts, Bing began that "minimum of effort" policy when he was a kid back in his home town of Spokane, Washington. Along with his four brothers and two sisters he was expected to do his share of household chores like cutting and bringing in wood, mowing the lawn, washing windows, helping with the dishes. Inevitably when the hour came for a certain job to be done, Master Bing was among the missing; either he was at the gym practising for the swimming championship he was to win later, or kicking a football around a corner lot, or in heavy conference with his fellow members of the first little band he organized.

"How he got away with it, I'll never know," Larry

In Defense of Laziness

said, "I guess Mother just was the first victim of the famous Crosby charm."

Bing pooh-poohed this idea, and said he never had been mother's pet; it was just fortunate that she had enough perspicacity at the time to recognize the infinite importance of a perfectly executed drop-kick as compared to the unimportance of a well beaten dining room rug on a Saturday afternoon.

Larry asserts that the only reason Bing always played the role of the victorious cowboy in the childhood game of Cowboys and Indians from which he got his nickname was because the "dead" Indians had to fall down. Bing labeled that a gross misstatement of fact.

"Rather let us say I choose to align myself on the side of law and order," he suggested.

Of course it is perfectly true that he once got a job as a farm hand and was fired after one week. But it was not because he was loafing on the job. He merely had acquired $2.00 in pay and felt it only fair that employment should be spread around among as many as possible in hard times. Nor did he deliberately cut his foot with a hatchet that time he worked in a lumber camp. That is a base piece of propaganda, says Bing.

"Yes, sir, it sure is a puzzle to me why people go 'round saying I'm lazy," Bing said and slid further down in his chair until he was sitting on a spot between his fourth and fifth cervical vertebra. "Now, for instance, last week we found our show running overtime. I insisted we cut one of my vocal numbers. So my brother says 'You're not fooling me, you lazy lunkhead. That's not modesty. You just want to get out of a little work.' And here I'd gone to the trouble to figure it out like this: the less you give them, the more they want and the more they want, the longer I'll have a job."

Sure, he sits perched on a high stool when crooning those ditties the public loves, Bing admitted. But it's not because it is too much work to stand up to sing the way others do. It's simply that he sings just as well sitting down as on his feet, and look at the wear and tear on shoe leather it saves! Doesn't cost half as much to half sole the seat of your pants as the bottom of your shoes. And besides, it's more comfortable.

Furthermore, it is not laziness that makes him sign important contracts without reading them through as brother Everett claims. The very idea!

"I pay a good lawyer a heavy chunk of dough to take care of things like contracts," he defended. "Now as I see it, your lawyer is something like your doctor. You've got to have faith in him and his judgment, or there's no use having him take care of you. Right? So, signing contracts without reading them simply is my way of proving my faith in my lawyer. Besides, I don't like to read."

Once in a while that policy leads to a few difficulties, Bing admitted, but there's usually a way to get around them without too much fuss and feathers. Like the time he wanted a certain entertainer to appear as guest on his program. The guy was broke, his wife was in the hospital, and a jolt of $300 would come in handy. Unfortunately, however, the producer of the show did not see eye to eye with Bing as to the advisability of hiring the guy for that amount of dough. In fact, he didn't want to hire him at all. Technically he was in the driver's seat, because the contract Bing had signed without reading gave him jurisdiction only over what songs he, himself, would sing each week.

"Hire him," said Bing.
"No dice," said the producer.
"It's a good idea," Bing suggested.
"It stinks," said the producer.
"Mmmm," mused Bing. "Want a crooner on your program next week?"
"Certainly," said the producer. "You know damned well you're the spark-plug of the show."
"Mmmm," said Bing. "Then hire the guy. For three hundred bucks."

The guy was hired. For three hundred bucks. What's a contract anyway?

■ By all rights you should have been seeing Bing in a new Paramount picture along about now called *The Star Maker*. It was supposed to follow the current *Paris Honeymoon* and was scheduled to start early in September. Paramount isn't the least surprised it hasn't started yet. Things like that are more or less expected now with Crosby pictures. However, it is the blackest sort of calumny to even hint it was Bing's fault. Certainly he was *willing* to work. It was just that he was a very tired man and so he went to Bermuda for a vacation.

"It's pretty hard for me to understand why anyone would call that laziness," he said in a hurt tone. "All I was trying to do was show a conscientious respect for duty. A tired man cannot do his best work, and second-best is not good enough for my fans."

And as for what tired him out so much, anyone knows it is darned strenuous work watching bangtails run around a race track day in and day out for a whole month. Well, Bing thinks so anyway, and the United States constitution guarantees a man the right to his own opinion.

■ Then there was that night not long ago when he and Dixie had retired for the night, only to be awakened by a dripping faucet in the adjoining bath. The noise kept up until Dixie's nerves were frazzled. Bing lay quietly staring up at the ceiling.

"Bing, for heaven's sake, will you get up and do something about that faucet?" Dixie demanded at last.

"No, my sweet," he answered. "Put a pillow over your head and forget about it. We'll call a plumber in the morning."

"You lazy oaf!" Dixie said in exasperation. "I'm surprised you don't hire someone to do your breathing for you!"

"Tut, tut, my dear," Bing rebuked her. "Breathing is my job. So is crooning. But plumbing is not. And I am a man who subscribes to the principle that a shoemaker should stick to his last. Surely you would not ask me to violate one of my principles? Ah, I thought not."

Dixie put a pillow over her head and called a plumber in the morning. Bing rolled over and went to sleep. His "minimum of effort" policy had scored again.

Reading, writing and arithmetic go on just the same, even if these youngsters are working in a picture. Between scenes in Samuel Goldwyn's *Wuthering Heights*, starring Merle Oberon and David Niven, these youngsters hurry back to the "schoolhouse" in the corner of the set

■ There is a distinct difference between his policy and laziness. Bing is insistent about that. His idea of a really lazy man, he said, was the fellow he saw down South one day. The chap was sitting on the ground leaning up against a picket fence, feebly fanning himself from the broiling hot rays of the sun.

"Whew," he would say. "Sho' is hot. Yes sir, sho' is hot!"

A few feet away stood a large elm tree offering generous shelter of cooling, deep shade. Bing asked him why he did not move into it.

The chap squinted up at the sky. "Well, sir," he answered. "I figger another hour or so, and the sun'll move!"

■ Seriously, though, Bing has worked and worked hard since the time he was a boy. Everything he owns or ever has owned he has acquired by his own efforts. Mother and Father Crosby believed in giving their children food and a home. Anything more the kids wanted they had to get for themselves.

Maybe he is the laziest guy in the world. If so, it's a new kind of laziness, for he also has more irons in the business fire than almost any other young man his age today. He makes an average of three motion pictures a year. He is the star of a weekly radio program. He makes innumerable phonograph recordings month after month. He takes an active part in the management of the beautiful Del Mar race track. He trains and races a string of thoroughbreds. He is president of the Crosby Investment Corporation which has extensive real estate holdings. He runs a big ranch in California. He plays at least eighteen and usually twenty-seven holes of golf a day to keep in physical trim. He owns one of filmdom's loveliest homes, is the devoted father of four fine sons, and the co-partner in one of Hollywood's happiest marriages. The cut of his combined weekly earnings which Uncle Sam gets in income tax is enough to buy a shiny new battleship every year.

A guy like that ought to be allowed to wear his shirt tails outside his trousers if he wants to.

SING! DANCE! LAUGH! What a Happy Holiday!

Irving Berlin's
"HOLIDAY INN"

starring

BING CROSBY and FRED ASTAIRE

A MARK SANDRICH production

with MARJORIE REYNOLDS ★ VIRGINIA DALE ★ WALTER ABEL

LYRICS AND MUSIC BY IRVING BERLIN

Screen Play by Claude Binyon · Adaptation by Elmer Rice
A Paramount Picture

"I'LL CAPTURE HER HEART SINGING"
"LET'S SAY IT WITH FIRECRACKERS"
"EASTER PARADE"
"WHITE CHRISTMAS"
"LET'S START THE NEW YEAR RIGHT"
"ABRAHAM"
"SONG OF FREEDOM"
"I CAN'T TELL A LIE"
"HAPPY HOLIDAY"
"FEBRUARY 12TH 1809"
"YOU'RE EASY TO DANCE WITH"
"LAZY"
"BE CAREFUL, IT'S MY HEART"
"PLENTY TO BE THANKFUL FOR"

Visual Study Jacob Adrian Copyright ©2012-2014 All Rights Reserved.

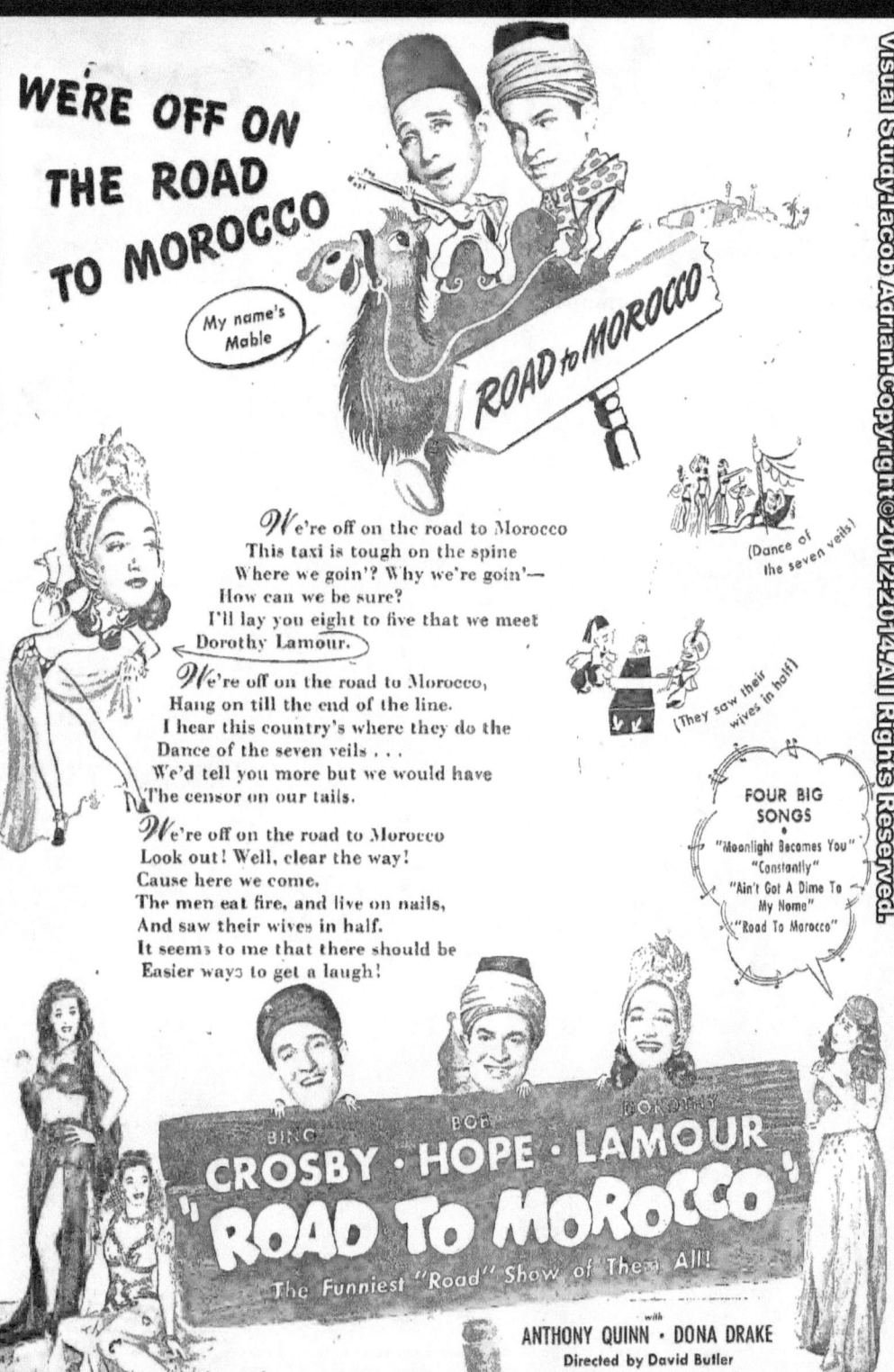

Elsie Janis Discovers

"I chuckle now as I remember how sorry I used to feel for him," confesses the famous stage star.

IT changes most people, that "Ole Davil Success," but I have never seen anyone grow more consistently charming, interesting and human with the mounting of each rung of the ladder of fame than has Bing Crosby.

Having fallen under the spell of that voice long before it echoed around the world, I sit back today and smile smugly at the doubters to whom I said way back in 1927, "Watch this boy Crosby!"

Some of them did. They now join me in a chorus of "I told you so's."

Many others, less credulous, probably don't even realize that the young man who has just signed a new contract with Paramount Studios, which will bring him two hundred thousand dollars in less time than it would take them to learn to croon, is the same lad who was permitted to sing a chorus now and then with Paul Whiteman's band six years ago.

When I say "sing," I mean sing. The word croon was still identified with mothers and lullabies. Crooners were as non-existent as the depression—personally, I think they were a great help to each other.

Bing has survived both. Paul Whiteman also, since he took his losses in pounds. In 1927, when Whiteman's name on a phonograph record was magic, young man Crosby sang proudly, gratefully, without acclaim and probably at a salary which would pay for the postage on one day's fan mail addressed to the Bing of 1933.

Last night I heard a radio announcer saying, "And now, at the request of many listeners, we will play Bing Crosby's latest song hit, 'The Old Ox Road' as recorded by Paul Whiteman." Bing, himself, was not singing, but the fact that he had sung the song made it important enough for a Whiteman arrangement.

THE Bing of 1927 was not the calm, well-poised Bing of to-day. He had an arresting personality, aside from the God-given, microphone-developed voice. His tones said clearly, "It is my heart that is singing to you," but his long dreamy blue eyes said, "Don't expect a lot of help from me, I'm not going to throw myself around for anybody."

His expression wasn't sad. It wasn't bored. It just wasn't "among those present."

I chuckle now as I remember how sorry I felt for Bing. I wanted to do something for him. He was, no doubt, perfectly happy, though I didn't bother to inquire, but only the fact that I was sailing for Europe saved him from being adopted, promoted, managed, or perhaps kidnaped.

All of the time I honestly believed it was because I wanted to help him. Right there we have the real reason for his world-

Bing and his first swordfish, caught off Catalina Island, after a forty minute battle. But, because it didn't weigh more than 200 pounds, he didn't win the Tuna Club gold button. But win it he will.

Bing Crosby's new house at Toluca Lake, near Hollywood, one of the swankiest in the film colony. It has just been finished. Be sure to read about the house-warming in "You Must Come Over," in this issue.

Bing Crosby's Secret

wide appeal. Sympathy! For example, take the records that have made him. "Stardust," "Just One More Chance," "I Surrender, Dear," "Now That You're Gone," "Faded Summer Love" and so on into the thousands of records. Always sad, sweet songs.

While the world has been going hi-di-hi-di, Bing has been doing half of the love making in it, by proxy. My own romance was a Crosby production—a lover's spat, a sad farewell, a turn of the radio dial, Bing singing "Just One More Chance" and I would bark my shins in my dash for the telephone to recall the young man who is now my husband.

No one can listen to Bing as he listens to Lawrence Tibbett, John Charles Thomas or any of those great voices which thrill you and leave you saying, "Boy, what a voice! He certainly can knock 'em for a loop!"

With them you feel that you are just a little listener, privileged to hear the glorious notes. You can almost visualize those big boy baritones, slapping the microphone on the back as they leave the studio, saying, "Thanks, Mike, old thing. I'll be seein' you, and you'll be hearin' me!"

With Bing it's a personal thing. He seems to be singing just for you and with one or two exceptions he always demands sympathy. Even when he asked the world to "Learn to Croon" via the screen, radio and records, it was much more of a request than a bit of advice.

I LEFT America for England in 1927 without helping Bing, the caressing Crosby quality (later to be called a croon) ringing in my ears. Months later an English friend of mine who apparently met the incoming ships from America to get a corner on all the latest American gramophone records, said to me, "I say, have you heard those Three Rhythm chaps? They're topping! Listen to this recording."

The needle dropped and we were into "Mississippi Mud," as recorded by the Three Rhythm Boys. I listened to the trio, feet tapping, eyes snapping, three voices with but a single rhythm. Suddenly my ears stood right on their lobes as I heard the solo bit, "For I Left My Sugar Standin' in the Rain and My Sugar Melted Away." "That's Bing Crosby," I cried. "It couldn't be anybody else." Well, it was, of course.

Life became one unending search for other Rhythm Boys records and, above all, one where Bing would sing more alone. I still felt sorry for him, still wanted to help him. By the time

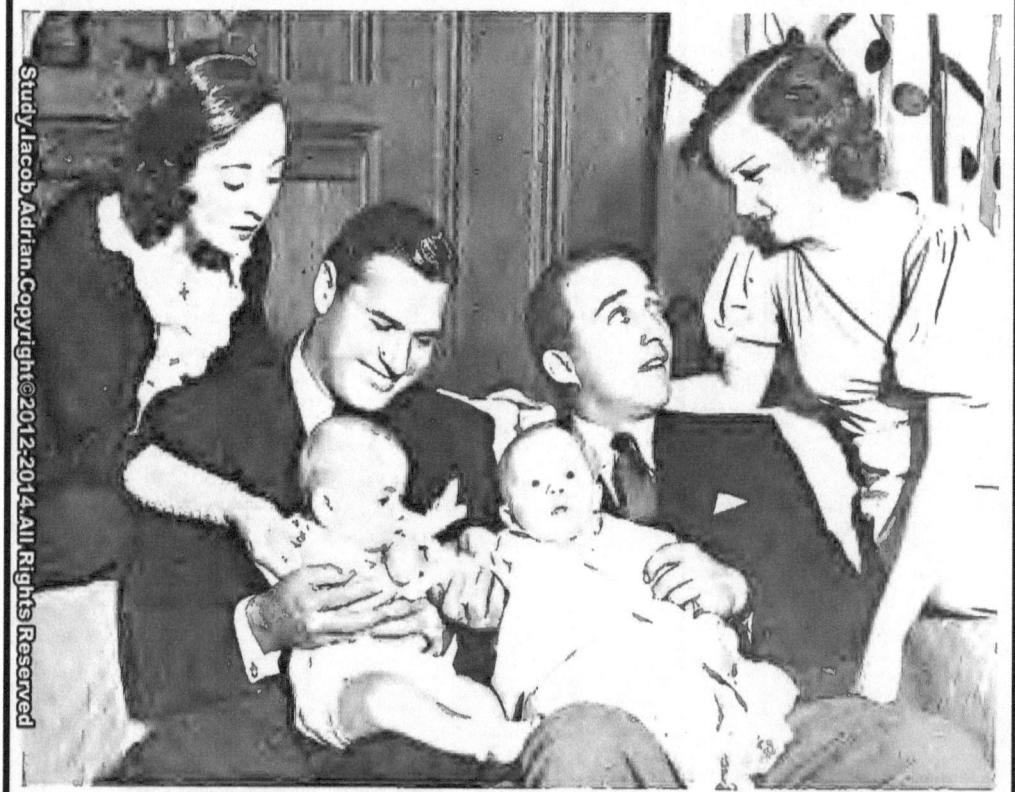

Bing, holding his newborn, at the son's christening recently. Others in the group are Jobyna Ralston Arlen and Dick Arlen and their son, Richard Ralston Arlen, and Dixie Lee (Mrs. Bing Crosby). The babies were christened together.

Bing Crosby's Secret

I got back in America he had helped himself to a lot and he is not ready to stop doing so by any means.

In 1929 I met him at a party in Hollywood. He and the other two Rhythm Boys, Harry Barris and Al Rinker, were out here to appear with Paul Whiteman in "The King of Jazz." That production was the last of a cycle of screen revues. It was almost as stupendous as the Boulder Dam and took nearly as long to be completed.

I never saw it, having temporarily lost my enthusiasm for musical pictures. This year they have brought it out again. The newspaper advertisements here on the Gold Coast read, "Bing Crosby in 'The King of Jazz.'" I believe that he only appears as one of the Rhythm Boys, but if he were just in the ensemble he would still get the billing today. The worst part about being the man of the present is that the man of the past is always being dragged in to take a bow or a slap. Bing's past rates mostly applause, I'm sure.

THERE were a few months of "going Hollywood" and the party where I met him was right in the midst of the voyage. I still felt sorry for him, though he obviously was sitting on the crest of a wave of whoopee. He dived off before anyone could pull it out from under him.

Bing, Barris and Rinker were the toasts of Hollywood. They were all three drinking toasts to most anyone. Night after night they were the life of those parties which must have life even if death follows disguised as lost prestige.

Bing was singing divinely that night. Harry Barris was playing his own compositions which a few months later became the songs of the hour, Al Rinker, less spectacular, but just as important in his own quiet way, was contributing his harmonious third to the trio, and, leaning on the piano with a sort of "They're not like this all the time" expression, was a very pretty little blonde. She is now Mrs. Bing Crosby, the mother of the still-quite-new baby Bing. I spent my time between hanging on the piano and telling people that something ought to be done about those boys. It was done very shortly, but not through any influence of mine, I'm sorry to say.

Every night now you can tune in on KFI, our local station, and hear a cheery voice saying, "We are taking you to the world famous Cocoanut Grove, the playground of the stars." Bands come and go. Phil Harris, Abe Lyman, Jimmy Greer and others. They are all good but most of the "world fame" credit must go to Gus Arnheim, who not only had a fine band at the Grove that eventful year but was expert showman enough to grab the Three Rhythm Boys and inside of two weeks start featuring Bing Crosby as soloist.

It was there that little Harry Barris dashed off song hits so fast that by the time you had memorized "Beside a Shady Nook," he had you humming "Just One More Chance." No sooner had you agreed to give up your Shady Nook for that One More Chance than it was "I Surrender, Dear," then "At Your Command."

Bing Crosby's Secret

That was just about a song hit a week, but I'm wondering now just what would have happened to those songs if it had not been Bing who sang them. They were lovely, but they have gone the way of many songs, while Bing is still starting every song he sings on the road to certain popularity.

I believe Bing is just one of those chosen people who arrive to remain in spite of all efforts to find someone quickly to replace them. They tried to rob Bing of his place in the sun before he had even felt the full strength of its warmth. He was the rage of the Coast. Men liked him as much as women. That was a help when all around town parties would call off games, dancing, bridge and gossip to gather around the radio at eleven-thirty listening to Bing.

When we heard he was going to New York it was really a blow, but we were reassured by the fact that he was going to broadcast from there. For several sad last weeks he was still here, saying a series of farewells, due to the fact that Gus Arnheim realized the "playground of the stars" was about to lose one of the chief interests of the stars and tried his very best to hold him.

I'VE seen quite a bit of Bing during the last two years, both in New York and out here. He is modest, grateful and above all, humorous. He doesn't want to play the romantic lover. He likes light comedy which, to use his own phrase, "takes the curse off the crooner business." He has a new baby, a new contract, a new house, all acquired by his own efforts, but the foundation that made it all possible remains the same.

He has no ambition to develop that voice into something bigger or change his style. He wants to hold what he has earned, the title of the world's sweetest singer. That's not his admission, but it's my contention. Bing will do whatever he sets out to do. Behind the calm blue orbs there lies the fire that you hear in his singing, smouldering perhaps. But just try to put it out!

As a proof of his "stick-to-it-iveness" I submit the following word picture... The island of Catalina, the Capri of California. Miss Janis, following the President's suggestion to spend, breaks out and charters a yacht. It is swordfish time at the Island. Miss J. thinks she would be satisfied with a few mackerel but goes ashore to buy some heavy tackle just in case... Dinner on shore and the return to the yacht which lies at a mooring, probably saying to itself, "I hope she isn't going to start running me in circles after one of those (sea captain language deleted) swordfish." Seated on a bench near the club landing, alone, except for a two days' beard and a pipe, is a man. Miss J. doesn't glance at the lone figure until it rises and somewhat blocks her progress.

Miss J.—"Bing! What on earth are you doing here—er—I didn't know you—" Bing—(without a smile) "I'm after a swordfish. I've been trying to get one for three years. Every time I can get a few days off I come over here. I won't stop till I get one."

Miss J.—"But, are you all alone?"
Bing—(Still smileless) "Yes! I couldn't get anyone to come with me. Dick Arlen's working, so's Jack Oakie. But I don't mind, I just go out with a fisherman and—"

Miss J.—"How's Mrs. Crosby?"
Bing—"Fine! I had a strike today; got him up to the boat and lost him. It was terrible. I—"

Miss J.—"How's the new baby?"
Bing—"Swell! Did you see the fish Thomas caught today? Three hundred and forty pounds. It's hanging out there at the end of the pier. I was just out there looking at it—"

Miss J.—"I hear you've just signed a new contract—"

Bing—"Yeah! That guy landed that fish in twenty-eight minutes." (Our hero looked as if he was going to sing "Just One More Chance" any minute.)

Miss J.—"Want to come out on the boat for a glass of beer?"

Bing—(Looking at watch) "No! Thanks, just the same. It's nine-thirty; I've got to turn in. I start out at six in the morning—"

Miss J.—(Very near tears) "Well, better luck tomorrow, Bing. I have a hunch you'll get your fish!"

AND he did start out at six. I watched him go, though he didn't know it. At a little before noon I saw one of the fishing boats headed for the pier, flying the swordfish flag. Without looking through the glasses, I knew that it was Bing. It just had to be.

The Captain, my young man and I rushed to the pier to welcome the conquering—and, I supposed, satisfied—hero. He was as calm as if he had been catching swordfish every day before lunch for years. Everyone on the pier was apparently more excited than Bing. They dragged the monster onto the scales. Bing watched intently. I didn't know that to receive the gold button from the Tuna Club, you must land a two hundred pounder.

I stood trembling with pride, thinking Bing's fish must be the biggest ever caught. The scales registered one hundred and eighty-six pounds. The triumphant fisherman registered complete disgust.

"But, Bing," I said. "Last night you were crying for a swordfish. Now you've got it, what more do you want?"

"I want a button!" His white teeth clenched on the stem of his pipe. "And I'm going out again as soon as I get a cup of coffee."

He fought the fish over forty minutes. He was called back to work without getting that button, but when I saw him the other day at the Metro studios where he is playing with Marion Davies, he said, "I'm afraid the swordfish will have stopped running by the time I finish here." He smiled in anticipation, as he added, "But there's always a next time."

My sympathy is with the swordfish or any other "poor fish" that thinks Bing won't eventually land him if he makes up his mind. He is that rare combination of gentleness and strength. Incidentally, I don't feel sorry for him any more, but I do feel sorry for the disgruntled sap who says that Bing Crosby is a temporary fad. If he is a fad, so is love; if he is temporary, so is music. Anyway, they're all three doing pretty well—so far.

Romance

"Give me the moonlight, give me the girl—" With this setting it is little wonder Bing Crosby sings beautiful love songs to Carole Lombard in "We're Not Dressing." This is the first time Bing and Carole have been together. From the looks of things we hope it is not the last.

You'll see here an ultra-modern boy and girl who have said farewell to the past and farewell to crinolines. Don't they look like brothers? The big fellow is Bing Crosby and the li'l fellow is Miriam Hopkins, in tweeds, and with her hair cut, for "She Loves Me Not." Just think what her grandma would have said if she'd seen Miriam togged out like this.

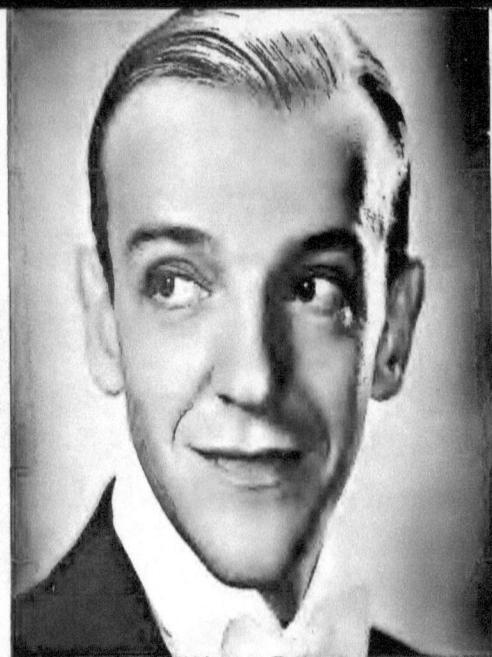

Outside of Valentino no star but Clark Gable, above, has appealed to so many women. Below: Warner Baxter, Dick Powell and John Boles—is their appeal too specialized?

Valentino was a dancer. How different is the nimble dancing of bubbly Fred Astaire! Below: Jimmie Cagney, Ronald Colman and Gary Cooper, too, show how times have changed.

COULD THE "SHEIK" WIN

The Great Lover, they called Rudolph Valentino. If he came back today, would he instantly outshine the other men of the screen? Or would he find himself outmoded, a man whose day was done? • By IRENE KUHN

IF Rudolph Valentino could come back today from that unknown world beyond the grave, would he be remembered? Would he at once regain his magnificent stardom, snatched from him nine years ago by death, jealous of his ardent, avid life? Would he be the screen's great romantic lover? Or would he be just another of the current favorites whose appeal is, in no single instance, the all-in-one quintessence of male magnetism and mysterious glamour that made Valentino?

Would Valentino today learn that the fickle feminine public no longer wants one man on the screen to have all their worship, but chooses to divide it among the reigning stars with voice appeal (Crosby and Powell); with dance appeal (Astaire); with drawing room appeal (Menjou); and with all the other varieties of male appeal possessed by so many talented young men today, each with his particular flair, each with his special following.

Almost a decade has gone since there passed from the lives of screen fans their great romantic idol, Valentino, the man who had everything, who was all things to all women, who moved as mysteriously and swiftly into death as he had into spectacular fame, who died at the height of his popularity.

Perhaps a million women, to guess conservatively, women of all ages, from all walks of life, of varying degrees of intelligence and susceptibility, took Valentino's passing as a personal loss.

Fifty thousand of them, in New York City alone, besieged the doors of the coldly commercial funeral parlors where the "Sheik" lay in state. They clawed and fought to get inside. Mounted police, perspiring in the August heat, were forced to charge the crowd of hysterical women, weeping for a man whose voice they had never heard, whose face they had never seen, except in its shadowy black and white image on the silent screen.

TO this writer, who saw the ghostly smile on Valentino's face as he lay in his expensive casket in that palm-studded, flower-banked funeral room, who heard the weeping of women filing past his bier, and the unbelievable clamor of others outside, the cries and pleas of assorted women fighting to break police lines to look upon the dead face that had epitomized the most important thing in the world to them—romance—it seemed then, as if Valentino *knew* that his oft-uttered prophecy was a true one.

For, more than once, this svelte, swarthy tango dancer with that intangible male magnetism that carried him so swiftly to fame and fortune, to public adulation such as is given to few men, had been quietly sure of his unique place in the movie world. He seemed to be sure with a confidence that was almost prescience, beyond argument and dispute, that attempts to find a substitute for him would

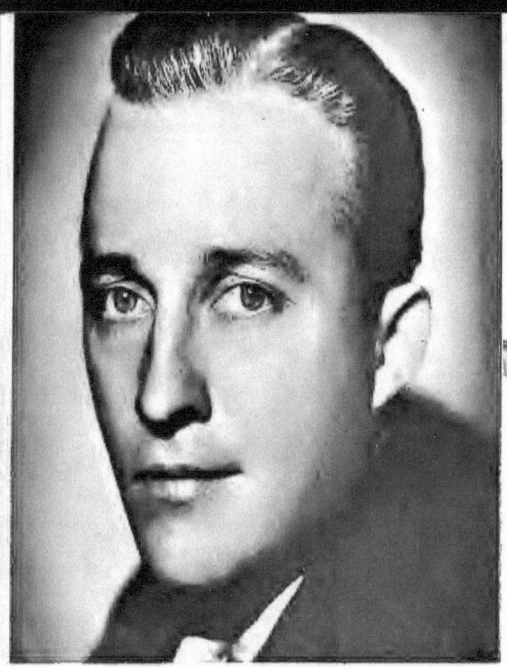

Bing Crosby's voice has the heart-appeal that Valentino had on the silent screen. If Valentino had talked—what then? Below: Fredric March, Herbert Marshall and William Powell.

HEARTS TODAY?

result in failure. "It can't be done," he always said. His prophecy has come true. It is possible now, almost ten years later, looking backward across a depression, across a vastly changed world of ever-shifting values and loyalties, across a revolutionary change in pictures that made them "talkie" instead of silent, to see that Valentino was right.

THERE has never been a successor to Valentino; it is doubtful if there ever will be a successor to him who, alone, will appeal so strongly to so many women. New heroes have their following. Numerically each is strong. But where, in the roster of the great stars, Gable, Montgomery, Cagney, Chevalier, Crosby—even Novarro who most resembles Valentino facially—Lederer, who comes closest to him temperamentally; March, Baxter, Astaire—is there one who, through the sheer force of his own personality has behind him a record of $1,000,000 and $2,000,000 and more single-picture earnings such as Valentino had in "The Sheik" and "The Four Horsemen of the Apocalypse?"

Valentino's death wrought havoc with the box office. Movie magnates searched frantically for his successor; the search grew more frantic as the possibilities were narrowed down and tried, one after another, without success.

The movie executives kept on trying. Year after year, through changing styles in heroes induced by fickle taste in screen drama, they pursued the search for a second Valentino.

"Romance! It is inherent in all persons, that desire, and lacking in almost all lives." So said Rudolph Valentino, when he was alive. "I understand that desire, and that is why they will never find my successor." Was it a true prophecy?

Could the "Sheik" Win Hearts Today?

Valentino's name came up again and again. The demand for another Valentino would not be stilled permanently, it seemed, until, finally, the women themselves solved the problem for the movie makers by abandoning their own desire for the one perfect screen hero who had everything, and compromising on dozens of men.

It became evident that some women liked some male stars for their he-man qualities; others for their drawing-room manners; others for their humor; others for their love-making.

It became apparent, too, that some male stars appealed to certain types of women, and to them alone. But no star, except Clark Gable, has appealed to so many different types of women, and Gable thus becomes the closest runner-up to Valentino. Yet, popular as he is, he has not ever come within the circle of complete appeal—again, all things to all women—as did Valentino.

There are women now who go to pictures to hear voices—Bing Crosby's, Nelson Eddy's, Dick Powell's, John Boles'. There are others who are Fred Astaire fans because of his inspired dancing. Still others go for the continental appeal of Robert Donat, Maurice Chevalier, Francis Lederer.

The dark, suave, iron-fist-in-white-kid-glove type like Ricardo Cortez, George Raft, Jack LaRue, attracts a number of women; the airy, charming type, sophisticated in the best Park Avenue manner, boyish, lightly romantic (like Fredric March in his lighter moods, and Bob Montgomery, in most of his roles), draws other women.

The American Arrow-collar-ad, regular-guy type, the kind of man who can be man-of-the-world and yet boyishly awkward, appealingly clumsy and pretty much like the men in real life that American women know best and usually marry—Gable, William Powell, the always dependable and durable Ronald Colman (with the touch of the buccaneer, the adventurer), Gary Cooper, Franchot Tone, Ralph Bellamy—even Herbert Marshall and Leslie Howard fit into this pattern—are the choice of a greater number of women from more varied strata of life than any others.

Eddie Robinson and Jimmy Cagney have their own following—the gangster brutality of their earlier pictures appealed definitely to many women; their unique personal attributes—neither can be called handsome, yet each has a compelling charm—in less sordid, brutal pictures—that has won them new fans.

THERE are many other male stars who number thousands of women as their worshipers; but those above are the ones with the largest, assorted feminine following—dowagers and debs, professional women and housewives, rich girls and poor ones.

Radio, which has advanced materially since Valentino's time, created a tremendous audience for Bing Crosby, the original crooner, before anyone ever saw him on the screen. The peculiarly ingratiating quality of his voice, with its "heart appeal," its romantic undertones, its wistful, nonsensical "bub-a-bub-bubbings," trailing off into humming and whistling, had feminine ears glued to radio receivers to the infinite disgust of husbands who hate all crooners on principle. The voice had so much sex appeal women wanted to see the face; so he went into pictures. They did a lot for him. He was a little chubby at the beginning; his rounded outlines did not fit into the picture of slim romanticism the radio listeners carried; but their loyalty was great, and Crosby slimmed down. His voice is insured for $100,000.

He's five feet nine inches and weighs one hundred and sixty-nine pounds. He's thirty-one years old, married to Dixie Lee, and the father of three boys, a single and twins. He wears a hat when he sings because he is slightly bald and is nervous about a toupee.

When he was in Paul Whiteman's band he was a cut-up. That he admits frankly, now. "I was pretty bad," he says. "I got into fights and things like that. Whisky has ruined my career five times in five years. I don't touch it now. I can take it or leave it."

His $100,000 voice won him the biggest vote in the annual World-Telegram poll in 1934 as the most popular male singer.

Nelson Eddy is moving up in picture popularity on a voice, too. He used to be a switchboard operator for a plumbing concern, but found that too dull. He tried newspaper reporting but was fired for singing at work all the time. Then he sang outside the office and won a contest, going into the New York Philharmonic Symphony Orchestra and in Grand Opera with the Philadelphia Operatic Society. You'll remember him (if your memory is good) from the pictures, "Broadway to Hollywood" and "Dancing Lady," and you'll be seeing and hearing him in some more.

Dick Powell is Warner's fair-haired boy. In musical after musical from that musical-conscious studio, with the talented Ruby Keeler, Dick has made the box-office registers sing almost as melodiously as he does himself.

John Boles, a little older, with a wealth of stage experience behind him in "Little Jessie James," and other hits, was leading man for Geraldine Farrar in her light opera venture, and started in pictures with Gloria Swanson in the "Loves of Sunya." He's played singing and non-singing roles in about thirty well-known films; displaying a more and more finished acting ability and a voice that wins him more followers with each new film.

Fred Astaire of the nimble feet, is a name to conjure with on the screen, as his was a name to conjure with on the stage. With his sister Adele, now Lady Cavendish, he made the name Astaire synonymous with smart dancing; so smart he eventually became a "must" with the gentlemen in Hollywood who keep their fingers on the public pulse and hear it beat in advance for what it wants to see on the screen.

Adele and Fred parted after "The Band Wagon," the New York hit. Adele to marry her lord, Fred to try Hollywood. He did "Flying Down to Rio" for RKO, and "Gay Divorcee" and "Roberta." He is established strongly in pictures, now.

THE continental appeal of Robert Donat has registered hard with women fans in just two pictures he's made so far, "Private Life of Henry VIII" and "Count of Monte Cristo," the former a British film, the latter an American-made product, in which he was a sensation.

Chevalier, combining that French come-hitherness, gay-dogginess and provocatively-accented voice—and that

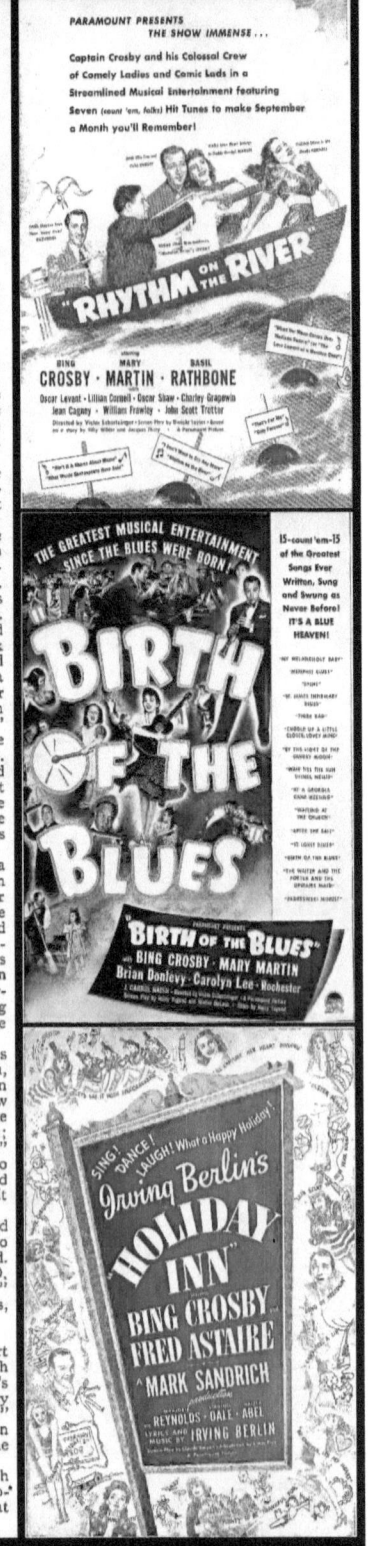

Could the "Sheik" Win Hearts Today?

accent is an asset of his personality—is among the high-priced male stars—$150,000 a picture, two pictures a year.

Francis Lederer, who made women swoon when he burst on Broadway in "Autumn Crocus" and revived the cult of the matinee idol, has dark brown eyes that glow like open fireplaces, and that intangible, provocative something in his temperament that Valentino had —but not to the same degree.

His screen career has not given him the opportunity to be the sensation among women that his two stage appearances in "Cat and the Fiddle" and "Autumn Crocus" provided. He was cast as an Eskimo by RKO in "Man of Two Worlds," a singularly inept choice for the young heat wave from Prague. Lederer, six feet tall, one hundred fifty pounds, has "it" and fire and the ability to excite by remote control, from across the footlights. ladies from suburban sewing circles, stenographers from Wall Street, debbies from Park Avenue, and co-eds from New England. He's 28. Give him time—and some good pictures.

CORTEZ, Raft and LaRue are the villain-you-love-to-touch-you type; and when they're heroes, they have about them a darkly sinister quality of brooding or actual mystery that gets the girls who like to guess and wonder—about the facts of life and the factors therein. Cortez, in particular, has a tearjerking quality that pulls women's hearts right out of their bosoms, a gift that insures his popularity with a large section of the more sentimentally inclined among women with deep-rooted maternal instincts intertwined with their romantic impulses.

Freddie March, Bob Montgomery and the gallery of 100 per cent American real-guy types—Gable, Tone, Powell, Baxter, Bellamy et al—are all exceptionally versatile actors who have played in a variety of roles, living courageously, dying heroically, laughing and clowning through life, being misunderstood and too well understood, being victims of wiles and the wily users of same—all in all, the kind of fellow who bobs up everywhere in America. You see him at the country clubs, the beaches, in the Pullmans, the transcontinental busses, on the steamers and the ferries, in the trolleys and the de luxe roadsters. He works in a bank sometimes, in a gas station often; he's a small town boy and a big city fellow. He's a cross-section of American male, this type. When he's glorified in the movies he's every girl's ideal, for he's the prototype of her adored brother, her football hero, her fiance—and always, the husband she'd like to have.

English stars who have won American women fans are Leslie Howard and Herbert Marshall and Ronald Colman. Howard, a great actor, with a delicacy and strength, with a spiritual quality and physical charm, with sensitiveness and wit, has won a following that is as much intellectual as it is average. That, in itself, is a tribute. Marshall's appeal is also on the side of acting and charm—charm of an evanescent, undefinable quality the very mysteriousness of which makes him alluring.

When America was in the grip of prohibition and its attendant evils, when the gangster was glorified in movies because he represented a contemporary part of American life and was attractive even when he repelled, American women took to Edward G. Robinson and Jimmy Cagney. Both of them symbolized brute strength, ruthlessness; maleness rather than masculinity, a quality still appreciated by American women who like their men to be men.

They were so evil on the screen, these two, that they were attractive. They brought to life in movies the men whose dark deeds were being scrawled across newspaper headlines daily. They injected into life that fearsome quality that makes home more attractive and causes endless speculation about the evil doers.

With the virtual passing of the gangster on the heels of prohibition those qualities of rugged strength which had caused Cagney and Robinson to be selected to push people around, take others for rides, and go trampling roughshod on laws, conventions and life generally, were translated into more heroic, normal roles which in Robinson's case have been definitely inspring and thrilling and, in Cagney's, on the lighter, more humorous side, intensely amusing and entertaining—the tough guy with the heart of gold who gives the bully his come-uppance. The movie makers found that Robinson's ruthlessness would fit nicely into stories of earlier, ruthless Americans who pioneered in the creation of America as a great nation out of a wilderness. As Cagney is the embodiment of the independent middle-class young American, both these stars mirror a new and more constructive phase of life in these United States.

Valentino, wherever Valhalla is, must look upon the divided loyalties of women and find Valhalla even more satisfying.

Two and three and sometimes four thousand letters a day came to him, from his faithful fans, back in those early days when the screen had only one hero whose name was Valentino. Why? The answer is very simple. He gave the women what they wanted, what every woman everywhere wants. Romance!

"It is inherent in all persons, that desire," he said once, "and lacking in almost all lives. I understand that desire and I give to those who have it, release from sorrow, from pain, from boredom. I give them Romance, those who come to the darkened theater seeking in the shadowplay a little moment when they can get away from the harsh realities of life. And that is why they will never find my successor. It can't be done."

HE may have been truly prophetic, realizing perhaps that he symbolized an age that would pass with his passing, that era of the nineteen twenties, an age that was acutely romantic in its post-war desire to find in superlatives of joy, of freedom, of life, of love, a complete panacea for the black horror that had befogged all lives remotely, or intimately touched by the war.

So for Valentino, in Valhafla, the toast: *"Le Roi est mort"* must finish there!

No one can add, as is done when a king passes and his successor steps to the throne—*"Vive le Roi."*

There IS no new king to wish a long life. The toast is complete only when it is halved. It is a fitting epitaph, its finality a tribute to the one screen lover who meant all to all women.

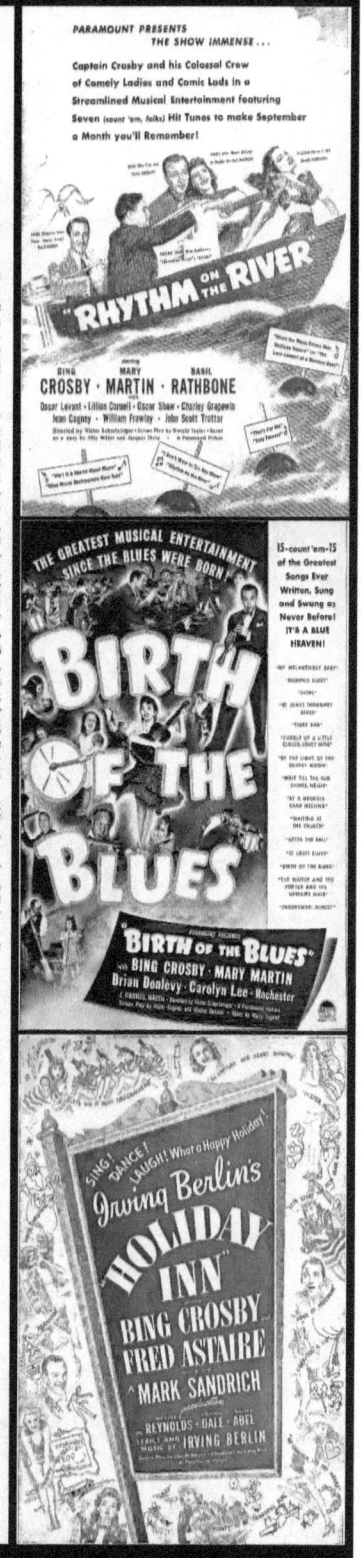

Bibliographic sources :

Hollywood (1934-1943)
Publisher: Hollywood Magazine, inc. ; Fawcett Publications, inc.

The New Movie Magazine (1929-1935)
Publisher: Tower Magazines, inc.

This documentary study use,
combined in various proportions,
elements from the following categories,
forms and subsets :
- fair use
- documentary
- documentary photography
- feature
- journalism
- arts journalism
- visual journalism
- photojournalism
- celebrity photography
in order to :
- employ material as the object of cultural critique ,
- quote to illustrate an argument or point ,
- use material in historical sequence,
providing independent opinion,
using photos, press articles, advertisements,
opinions of fans etc. ...

Copyright©2012-2014 Iacob Adrian
All Rights Reserved.

www.ingramcontent.com/pod-product-compliance
Lightning Source LLC
Chambersburg PA
CBHW021039180526
45163CB00005B/2188